IMAGES
of America

AROUND
AUBURN

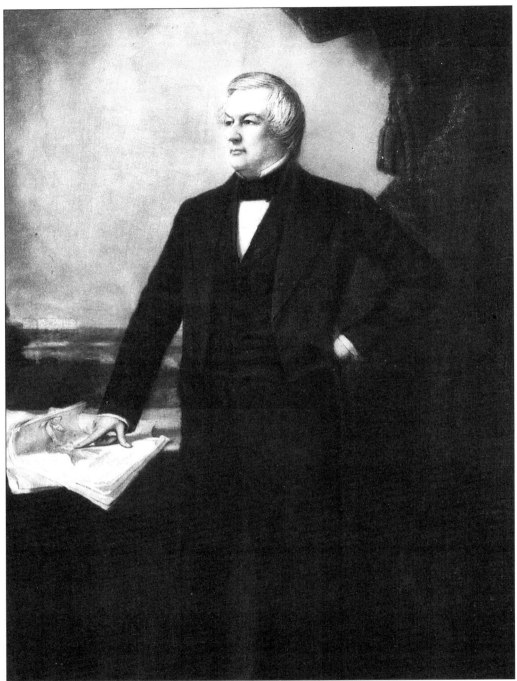

Millard Fillmore, the 13th president of the United States, was born and raised in the rural southeastern part of Cayuga County. His homes are now gone but the Powers house in Moravia where he was married is still standing. He inherited the office of president in 1850 upon the death of Zachary Taylor, and following a controversial term in office, Fillmore failed to win the nomination by his own party in the Election of 1853.

IMAGES
of America

AROUND
AUBURN

Peter Lloyd Jones
and Stephanie Przybylek

ARCADIA

First published 1995
Copyright © Peter Lloyd Jones and Stephanie Przybylek, 1995
Copyright © of photographs by The Cayuga Museum of History and Art, 1995

ISBN 0-7524-0225-0

Published by Arcadia Publishing,
an imprint of the Chalford Publishing Corporation
One Washington Center, Dover, New Hampshire 03820
Printed in Great Britain

Library of Congress Cataloging-in-Publication Data applied for

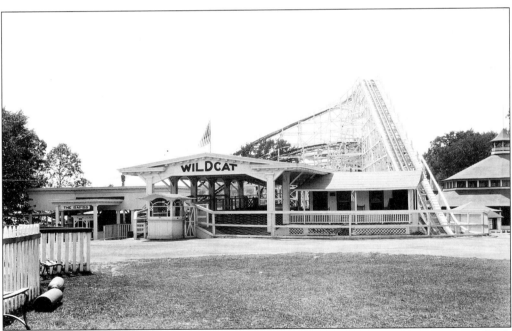

The Wildcat Roller Coaster, Enna Jettick Park, Owasco Lake. This large roller coaster was built by the Philadelphia Toboggan Company in 1930 and remained a popular attraction until wartime shortages closed the park in 1942. It is one of many park amusements still fondly remembered by older generations.

Contents

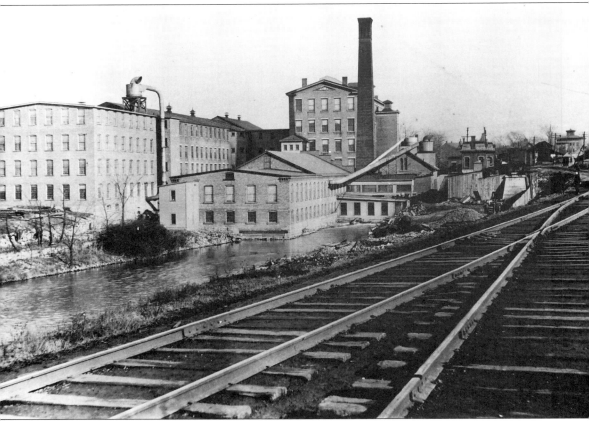

The Dunn and McCarthy Factory, late nineteenth century. The company was incorporated in 1896. President F.L. Emerson, who assumed leadership the same year, was the first person to adapt assembly line methods to the shoe industry. Emerson's promotion of Enna Jettick shoes—a pioneering effort in national advertising campaigns—included sponsorship of the Will Rogers Radio Show in the 1930s.

Introduction

This brief photographic history of Auburn, and sites around Cayuga County, was compiled solely from the collections of the Cayuga Museum. It is an introduction to the events, places, and people that shaped the history and character of this region from the earliest years of photography through the 1940s. The pictorial history presented here is but a few small swatches from the diverse fabric of this area's expansive history.

In the years following the close of the Revolutionary War, veterans and others headed west to settle the first frontier of their new, sovereign nation. This western frontier included what is now known as Auburn and Cayuga County.

The first person of European descent to settle this county was Roswell Franklin, who, in 1789, built his home on a bluff overlooking Cayuga Lake in what is now the village of Aurora. The area around his home included thick forests of elm trees, streams and lakes offering unlimited amounts of drinking water, and the remains of the defeated Cayuga people. Unfortunately, a few years later, despondent and depressed after being defrauded of his land, Roswell removed himself from both Cayuga County and this world, by his own hand. Having come and gone sixty years prior to the invention of the camera, Roswell left behind no photographic documents of the area.

Once opened to settlers, the development of Cayuga County set off at a rapid pace with veterans of Sullivan's campaign laying claim to areas they recorded during their days of warring with the Cayuga. Among these veterans was John Hardenbergh, who in 1792 settled his claim on the Owasco Outlet and established a village that in twenty-five short years would be a thriving metropolis with a new state prison. Originally called "Hardenbergh's Corners," the village's name was soon changed to one intended to reflect a more "dignified" and progressive image.

The name chosen, however, was one of irony and contradiction. Named after the fictitious village of Auburn, in the poem *The Deserted Village* by Oliver Goldsmith, the name to some foretold of a bleak and empty future while to others it represented a romantic connection to the desirable qualities of small town life. For a growing community that was actively attracting industry, such a choice for its name belied a desire for the best of two conflicting worlds: industrial prosperity and rural values. But this contradiction was neither foolish nor short-sighted. Eventually, more than thirty other villages and cities in the United States would share

the same dreams, hopes, contradictions, and name.

Bypassed by the Erie Canal, the railroad, and eventually by the New York State Thruway, Auburn has had to define itself almost independently. It is because of its location away from the main lines of transportation that Auburn has been able to maintain its small size. And its unique character.

Good or bad, the central feature that has defined the history of the city of Auburn is its state prison. The prison initially attracted industry to the city because of its resource of inexpensive, forced labor. The days of forced labor are long past and today the prison remains itself as one of Auburn's largest industries. Nearly all of the factories built along the outlet through central Auburn are now only memories with just the prison to remind us of the history that it shaped.

Auburn is centrally located in Cayuga County, which rests in the heart of the Finger Lakes region. Cayuga County is said to have more shoreline than any other in the state of New York. It is the only county that has shoreline on both the Finger Lakes and the Great Lakes. Not only does Cayuga boarder two Finger Lakes (Skaneateles and Cayuga) and have one completely within its boundaries (Owasco), but it also boasts shore on Lake Ontario. Today, the somewhat accidental rural character of the county is now an asset to its economic future. The many lakes that at one time limited travel are now a significant attraction for tourism.

The most striking feature of the first three chapters—Early Auburn, From Village Lanes to City Streets, and Inventions, Industries, and Commerce—is that for most of the sites pictured these images are all that remain. The changes to the city's landscape have been so dramatic one wonders if these pictures are not of another city altogether. But the past is not there to bemoan, it is there for us to learn and build upon. Some of the changes were by intent, others by accident, and as the community considers its future, these records can help to offer direction.

The chapter Citizens of the World will most likely shock those who are not yet familiar with the level to which this community was involved in world events. For the small size of Auburn, and the rural nature of the county, the number of its citizens that contributed to shaping the world is truly remarkable. A list of its citizens reads almost like a who's who of nineteenth and early twentieth century international history. This all makes it clear that Auburn was truly never a deserted village, but rather, a village that touched the world.

The authors and the Cayuga Museum would like to thank the many individuals who donated photographs to the museum. Donations such as these contribute greatly to the preservation of history, and it is because of these donations and that we were able to create this book and share these moments in Auburn's histories with everyone.

One
Early Auburn

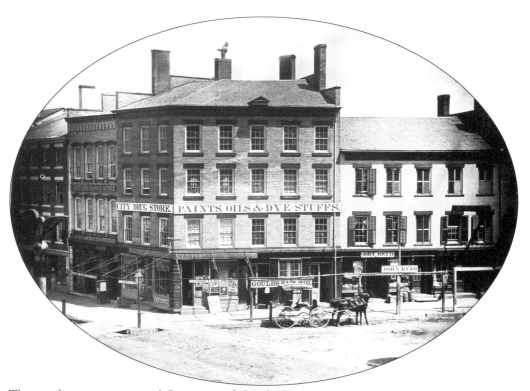

The southeastern corner of Genesee and South Streets, c. 1859. The City Drug Store and Gould's Hack Office, with a carriage parked at the curb, were two early Auburn businesses at the site of the later Cayuga Savings Bank.

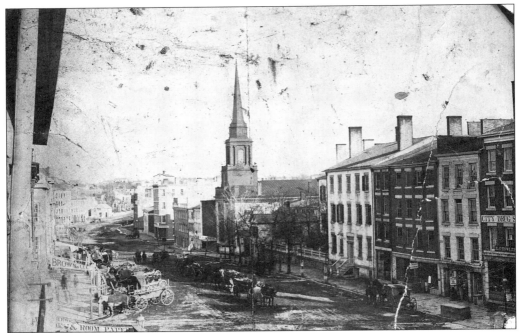

Genesee Street looking east, 1850s. The City Drug Store, shown elsewhere in this chapter, can be seen to the far right. As the city developed, Genesee Street became Auburn's main business thoroughfare. The old First Baptist Church, visible on the right, was removed to allow the construction of a theater which was later torn down to make room for Wegman's supermarket.

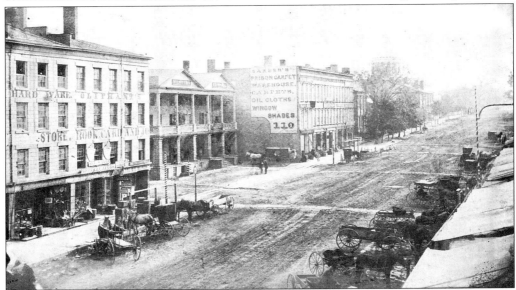

Genesee Street, looking west, c. 1850s. In the center of this photograph is the old Western Exchange Hotel. One of the earliest establishments in Auburn, it was started as Bostwick's Tavern in 1804. Revolutionary War hero General Lafayette was honored here with a ball during his return visit to the United States in 1825. The Western Exchange Hotel was razed in 1868.

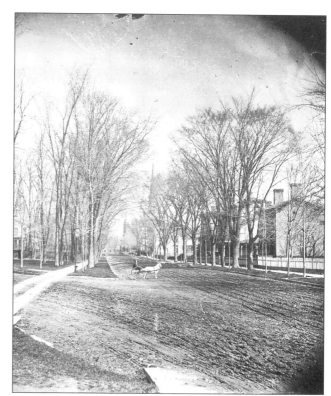

South Street, *c.* 1860. The current location of Seward Park is at the left. South Street has long been one of the more stately residential sections of Auburn. Even in the 1860s, however, goats were not a normal mode of transportation.

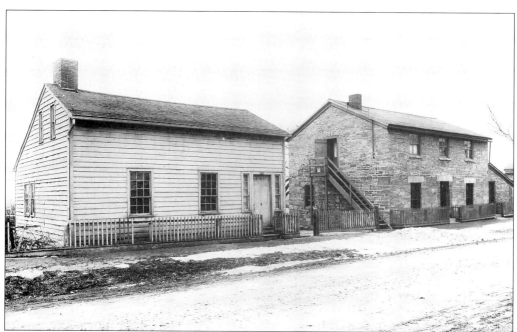

The blacksmith shop of Philo and Theodore Halladay, located on North and York Streets, is a testament to the widespread commercial activity in Auburn as early as the 1870s.

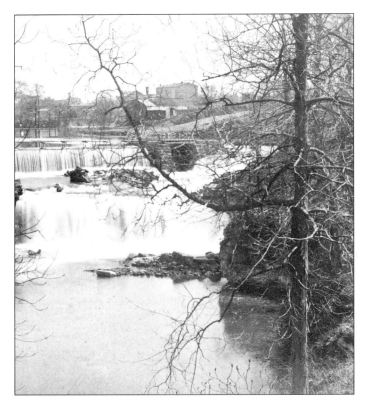

The Falls on the Owasco Outlet in the city of Auburn, 1866. The Owasco Outlet fell 180 feet as it followed its course through the city. This plentiful water supply, with its dramatic drop in elevation, was an important factor in the industrial development of Auburn and Cayuga County.

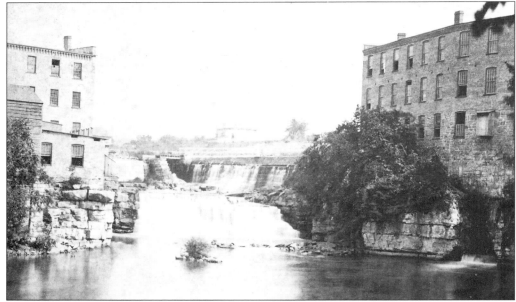

The Nye & Wait Dam and falls, 1876. An excellent example of the use of available water power on the Owasco Outlet was this factory complex at North Division and Clark Streets. The remains of the factories today include little more than the foundation of the building on the right.

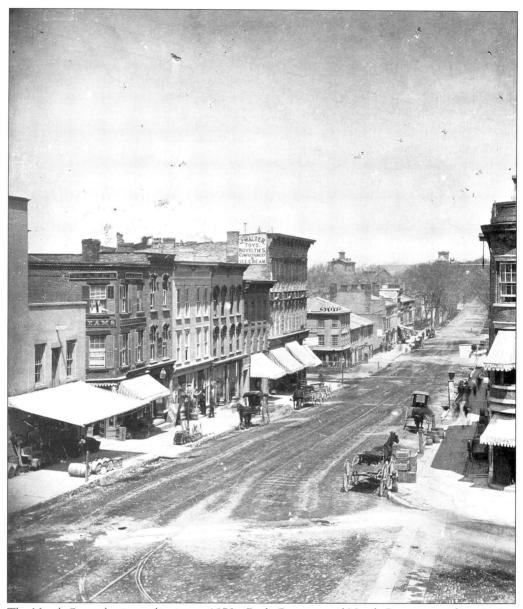

The North Street business district, *c.* 1870s. Both Genesee and North Streets were functioning thoroughfares in Auburn by 1794, just two years after the city was founded. As Auburn grew from a quiet tree-lined town to a busy industrial center, Genesee Street and the streets with which it intersected became the primary locations of business and commerce. Note the popularity of awnings during the late Victorian period.

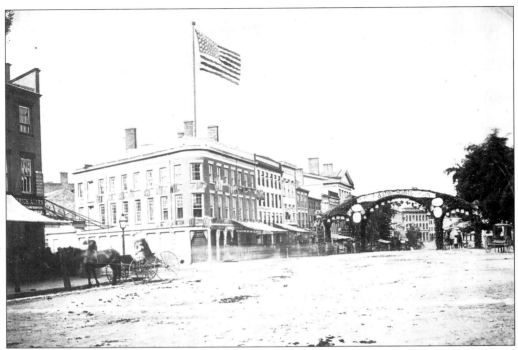

Victory Arch, Genesee Street, 1865. Two such arches were erected on Genesee Street following the Civil War, to celebrate the Union victory and as thanks to those men who served in local regiments. This arch was towards the eastern end of Genesee Street. The corner of North Street is at the left.

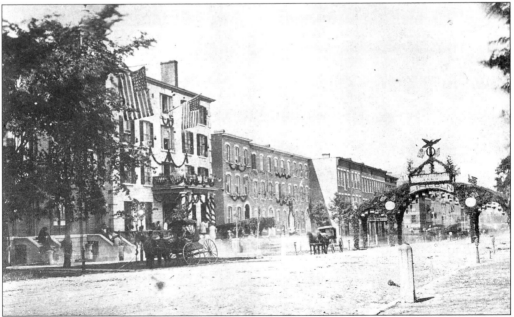

Victory Arch, Genesee Street, 1865. The other Civil War victory arch was located on the west end of Genesee Street, just east of the Cayuga County Courthouse.

Entrance gate, Fort Hill Cemetery, 1850s. The Fort Hill Cemetery Association was formed in 1851 and the cemetery was dedicated a year later. The site chosen for use as a burial ground was the picturesque Fort Hill, long considered to have connections to local Indian cultures. Before the hill became covered with trees, Fort Hill was a popular recreation area offering the best view over downtown Auburn.

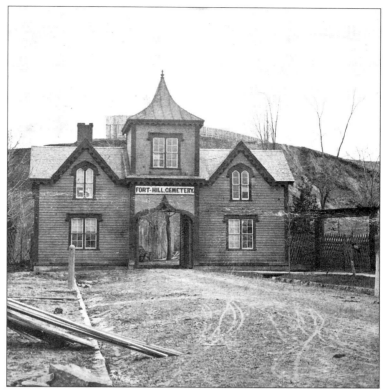

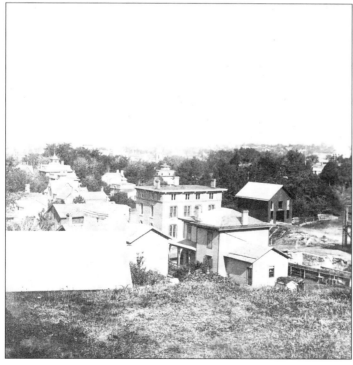

This splendid 1850s–1860s view of Auburn is from "Mount Auburn" of Fort Hill Cemetery. Mount Auburn, one of the mounds in Fort Hill Cemetery, is the highest point in the city.

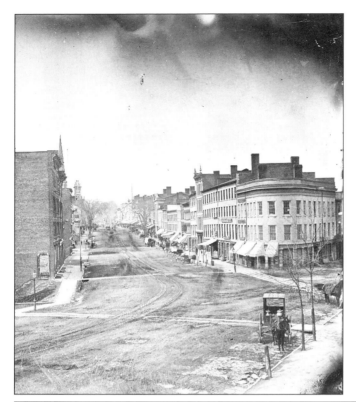

The intersection of Market and Genesee Streets, looking to the west. In the center right of this 1860s–1880 photograph is the distinctive Flat Iron building, which couldn't be saved even by its inclusion on the National Register of Historic Places. Note that the streets are still dirt-covered but the trolley tracks are in place.

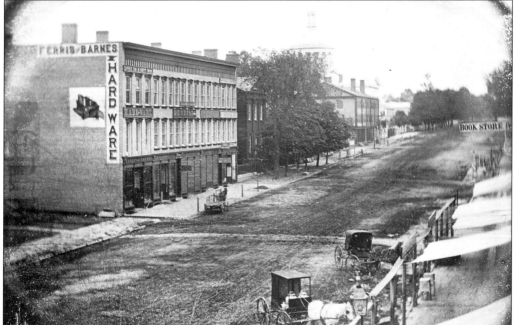

Genesee Street, 1850s. On the left in this picture can be seen the Ferris & Barnes Hardware store that appears in another view in this chapter as the Prison Carpet Warehouse.

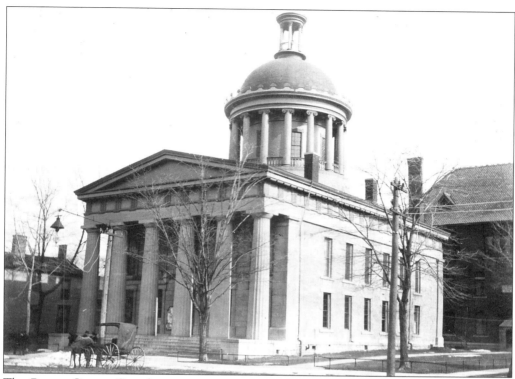

The Cayuga County Courthouse, 1850s. The building was constructed between 1807 and 1809 on land donated by William Bostwick. Its prominent tower was lost to fire in later years but the first two stories of the original structure are still in service today.

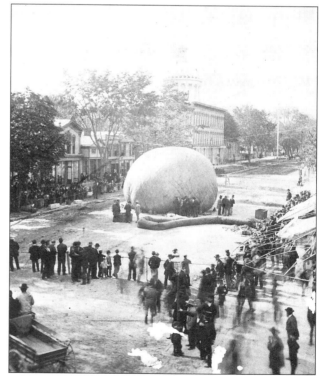

A balloon launch, c. 1860s–1880. Genesee Street has always been a focus for community activity, balloon launches being among the more unusual events to take place.

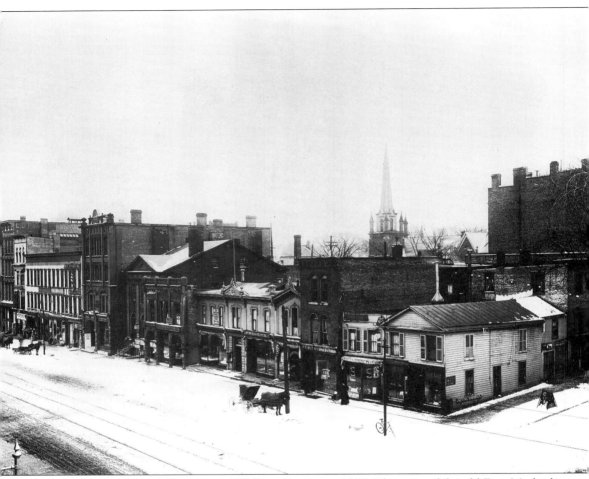

The intersection of Genesee and William Streets, c. 1880. The spire of the old First Methodist Church accents the Auburn skyline in this view of local businesses on a rather typical winter day in central New York.

Two

From Village Lanes
to City Streets

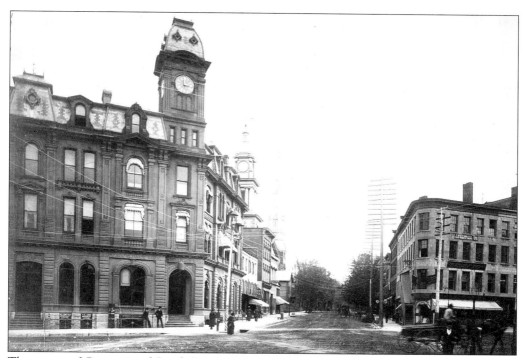

The corner of Genesee and South Streets, c. 1888. The familiar Auburn Savings Bank building, nearly the last vestige of the old business district, is at the left.

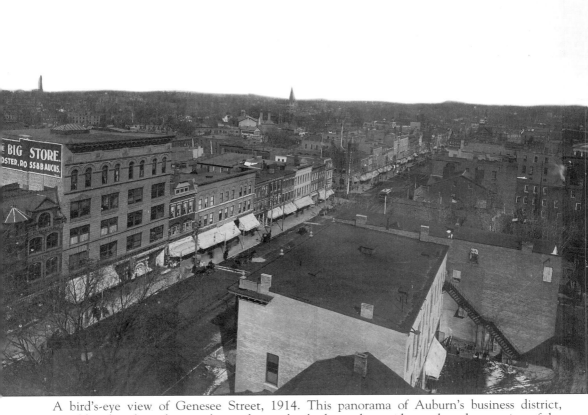

A bird's-eye view of Genesee Street, 1914. This panorama of Auburn's business district, possibly taken from the courthouse dome, clearly shows the rapid growth and expansion of the city during the end of the nineteenth century. Note the continued popularity of store front awnings.

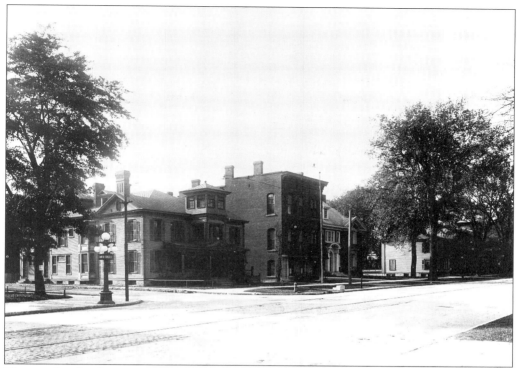

These unfamiliar houses were located on the southwest corner of Genesee and Court Streets in the early twentieth century. The property is now occupied by the Cayuga County Courthouse.

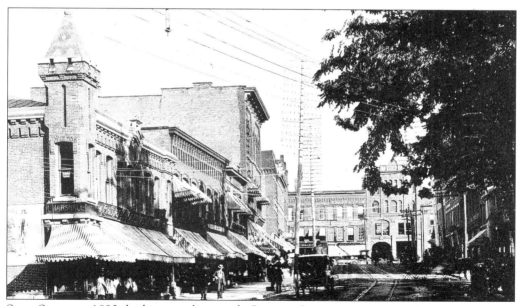

State Street, *c.* 1890, looking south towards Genesee Street. Attractive, colorful awnings and shaded sidewalks were once common features in downtown Auburn.

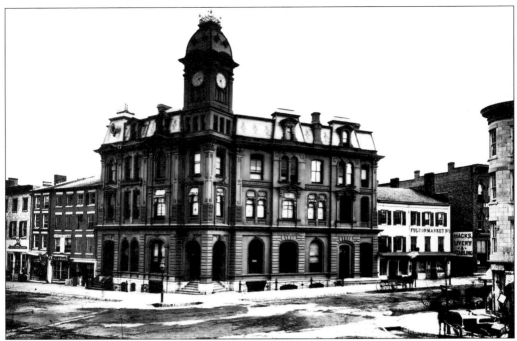

The old Auburn Savings Bank building, c. 1880, with its original entry way located on the building's corner. The clock tower is still one of Auburn's proudest landmarks.

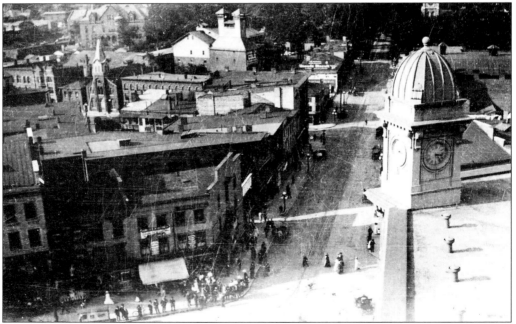

A bird's-eye view, north across Genesee Street and up North Street, c. 1900. This vantage point with the clock tower in view provides unusual perspective to the everyday activity below. This picture was probably taken from the steeple of the church that once stood on the first block of South Street.

The east side of North Street, 1876. Corning Hall, which later became Burtis Opera House, is at the right.

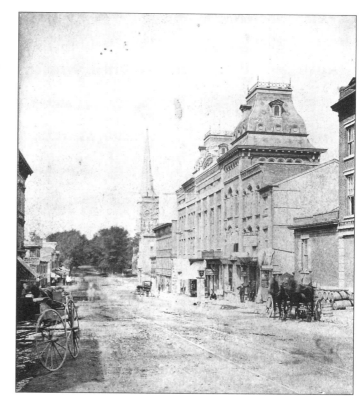

The east side of North Street, c. 1890s–1900, showing the Burtis Opera House with its two Mansard towers. Note how the opera house is framed by the many cables for growing transportation and communications systems.

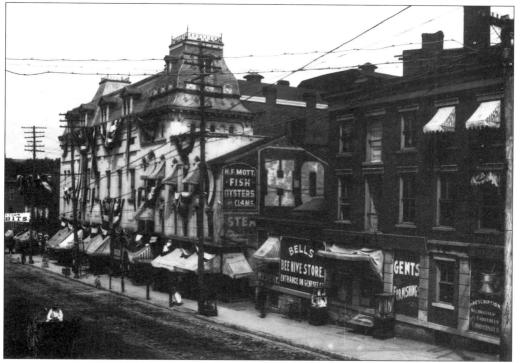

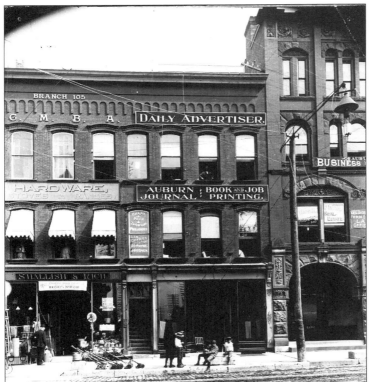

The *Auburn Daily Advertiser* building, Genesee Street, c. 1900. The foreground shows the that the street has matured from dirt to cobblestones.

Genesee Street, 1906. The combination of striped awnings and patriotic garlands created a festive atmosphere for the celebration of Old Home Week.

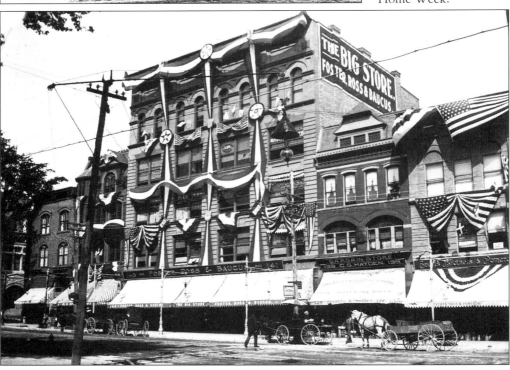

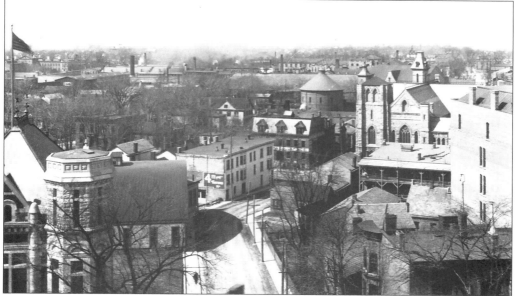

A bird's-eye view of Auburn in the early twentieth century. The old post office building is in the foreground at left. St. Mary's Catholic Church is visible at the right.

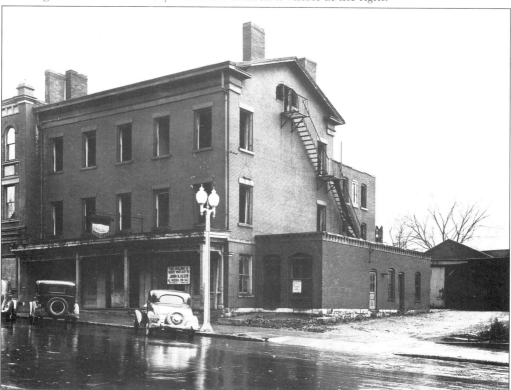

The Radney House, 1936. This was the end of the line for the Radney House, formerly the Farmer's Inn. The building was demolished shortly after this photograph was taken.

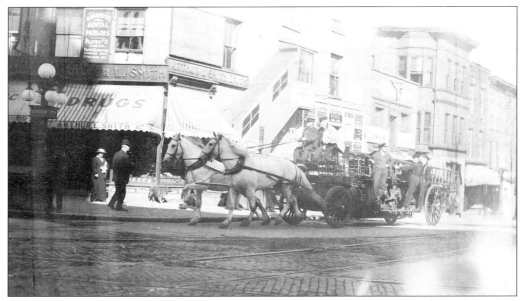

A horse-drawn unit responding to a fire at the intersection of Genesee and North Streets, c. 1900–1910. As all Auburnians know, fire has been an all-too familiar occurrence in Auburn's history.

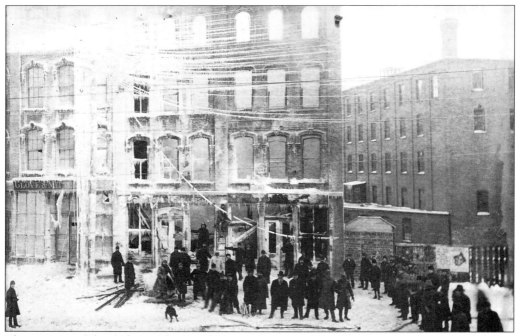

The remains of the Auburn Glove and Mitten Store, c. 1900. There wasn't always much left to save when local establishments burned, as is clear from the aftermath of this winter fire at the Auburn Glove and Mitten Store.

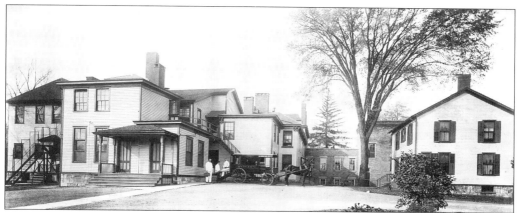

The Auburn City Hospital, c. 1904. This was the rear of the building, as it was visible from Park Avenue.

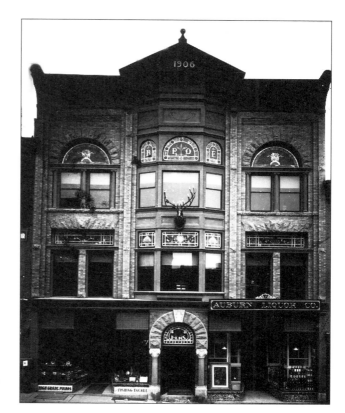

The Elks Club building, c. 1900. The uniquely decorative architecture of the Elks Club building was an attractive part of Auburn's skyline.

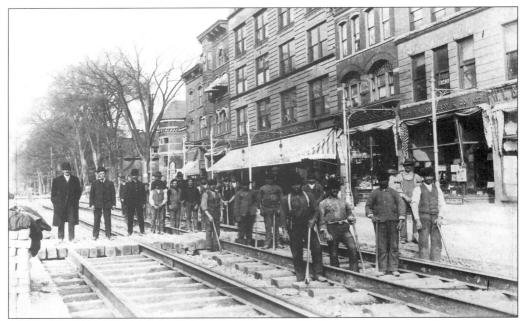

Laying the double tracks on Genesee Street, *c.* 1900. The advancement of transportation systems required many capable hands.

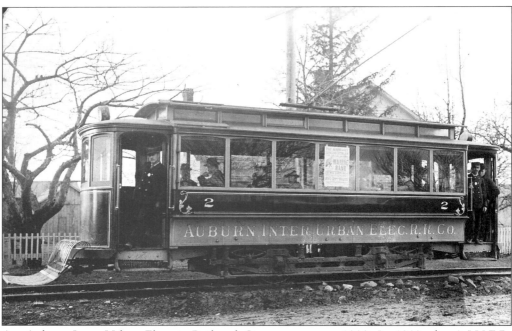

An Auburn Inter Urban Electric Railroad Company car, *c.* 1900. In 1903, the A.I.U.E.R. Company merged with the Auburn City Line to form the Auburn & Syracuse Electric Railroad Company. Note the rather unfriendly looking pedestrian catcher on the car's front.

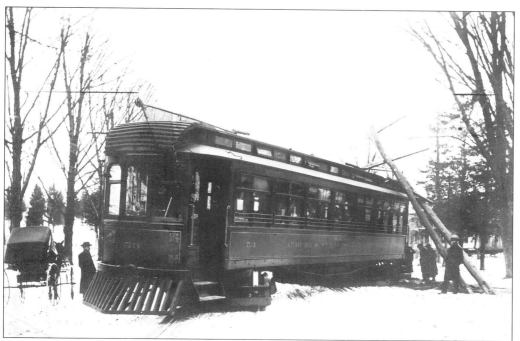

An Auburn & Syracuse Electric Railroad car off the tracks near Auburn, in the early twentieth century. Trolleys could get you where you needed to go, but the trip wasn't always smooth.

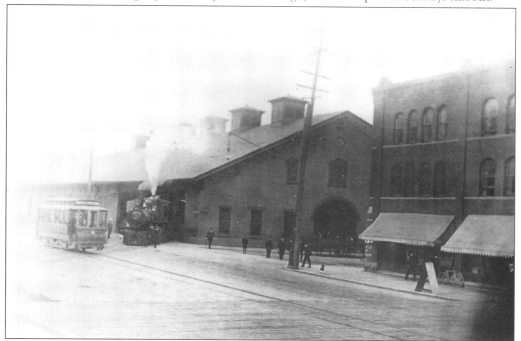

The Garden Street Depot of the New York Central Railroad, at the intersection of Garden and State Streets, c. 1890. The train is emerging from the State Street side of the old depot building, which was replaced by a new structure in 1906.

A view of the Lehigh Valley Railroad Depot, looking toward Clark Street, *c.* 1905. This north-south rail line carried passengers along the scenic west shores of Owasco Lake.

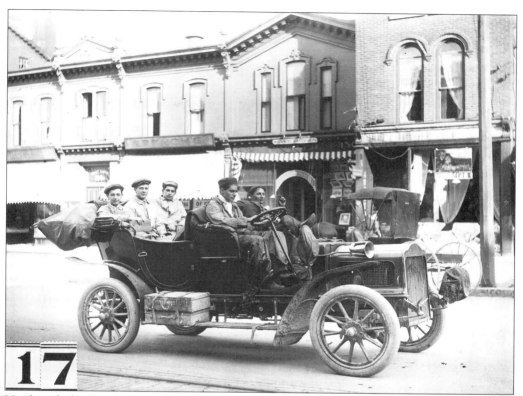

17

Unidentified riders, in an Auburn street scene from the 1920s. Automobiles were naturally a popular mode of transportation, even though it took years for the roadways to catch up the needs of the creatures.

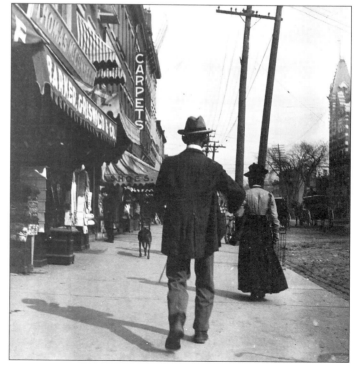

A view of Genesee Street, looking east, c. 1900. A man, a woman, and a dog, each enjoying the sun of the twentieth century.

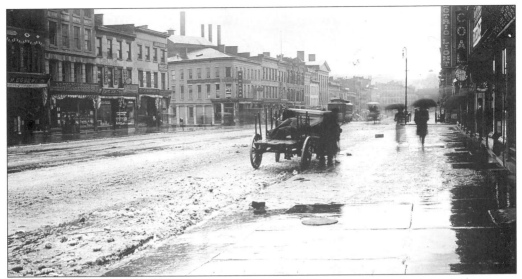

Genesee Street, 1909. Whatever the weather conditions, getting around in Auburn can sometimes prove tricky. Charles M. Austin snapped this photograph in front of Woodruff & Murphy's on Genesee Street at 10:45 am on a rainy March 9, 1909.

A view looking north up South Street towards the intersection of Genesee in the late 1920s. With automobiles superseding the horse and buggy, Auburn took on an even more definite urban appearance. For years, Auburn was the largest city west of Albany.

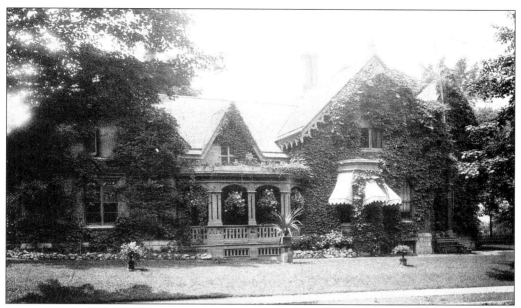

The residence of Josiah Barber, 37 Clark Street, *c*. 1890. Barber began a woolen business in Auburn using the manpower available at the Auburn Prison. He later founded Josiah Barber and Sons. His home exists today much as it appears in this photograph.

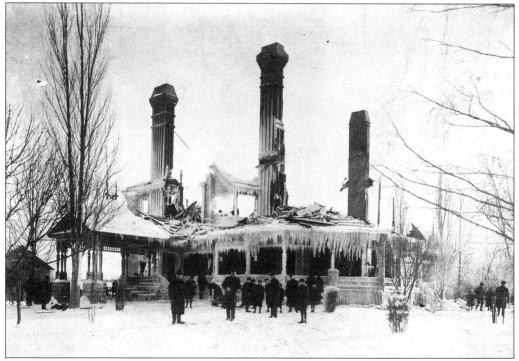

The residence of John L. Osborne, 130 South Street, January 1904. Once again, the aftermath of a winter fire is a familiar sight. After his home at this location burned twice, Osborne built a final version of brick and mortar.

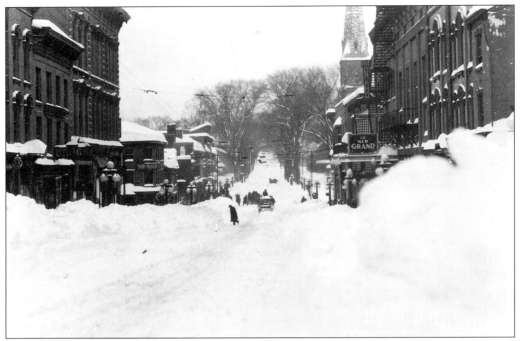

Harsh winters are certainly a fact of life in Auburn, as can be seen in this photograph of North Street taken on January 30, 1925.

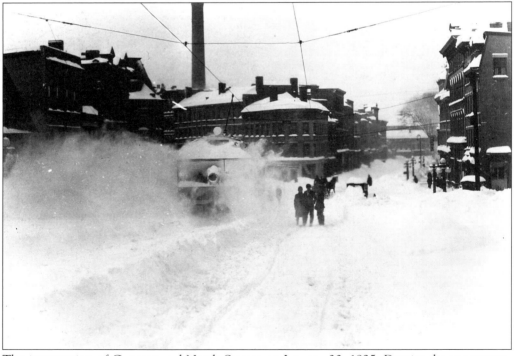

The intersection of Genesee and North Streets on January 30, 1925. Despite the snowstorm, the trolley tries to complete its run.

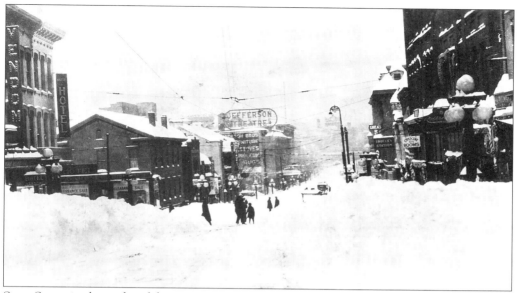

State Street in the midst of the snowstorm of January 30, 1925.

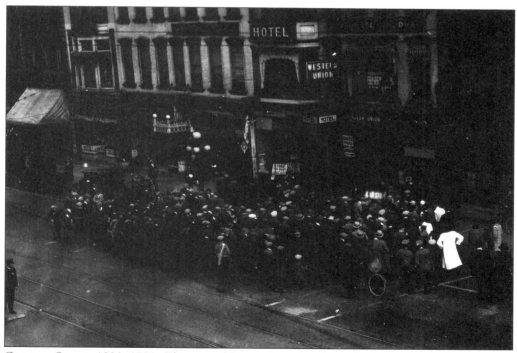

Genesee Street, 1920–1930. This crowd has gathered to hear the latest baseball scores and election returns.

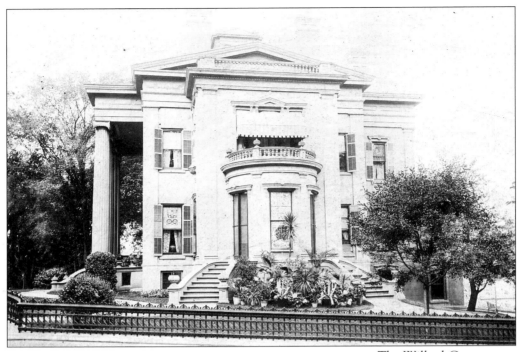

The Willard-Case Mansion, *c*. 1900. Built in 1836, this stately mansion was home to local physician and philanthropist Sylvester Willard and his family, and later to inventor Theodore Case. Today the mansion is home to the Cayuga Museum.

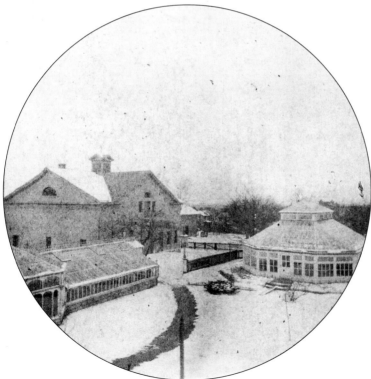

The greenhouses and carriage house of the Willard-Case Estate, *c*. 1880. The foundation of the greenhouse at the left was used for the Case Research Laboratory in 1916.

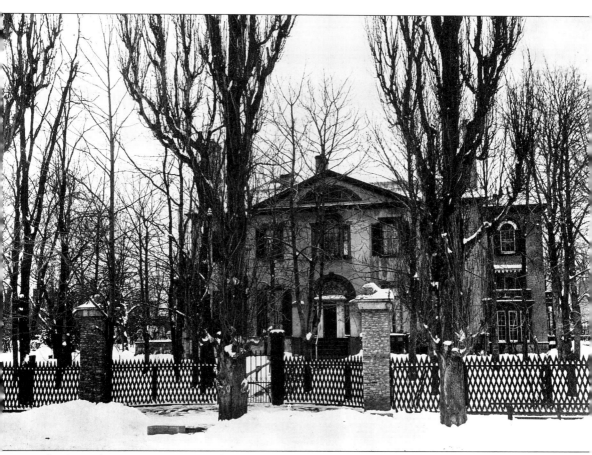

The Seward Mansion, c. 1880s. This building, home to Secretary of State William Seward and his family, was built by Seward's father-in-law Judge Elijah Miller in 1816. Interior architectural highlights include fireplace mantelpieces carved by Brigham Young. Today the Seward Mansion is a National Historic Landmark and is open to the public.

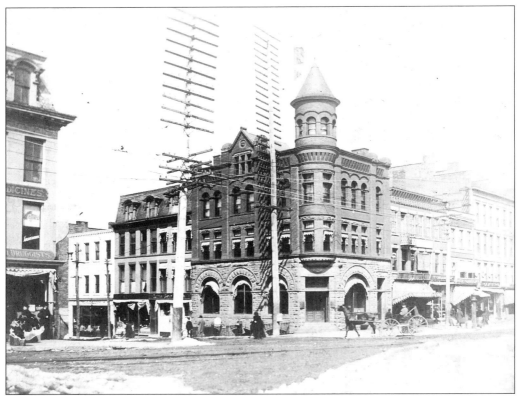

The Cayuga Savings Bank building, corner of State and Genesee Streets, 1880s. This stately Romanesque Revival building was a familiar Auburn landmark throughout the late nineteenth and twentieth centuries until its removal. Note the few power lines decorating the street.

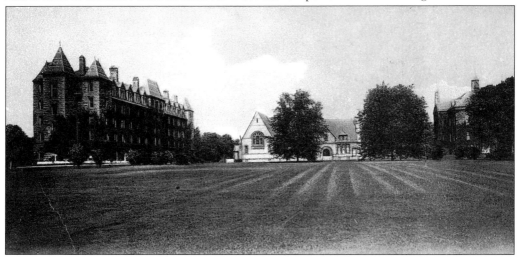

The Auburn Theological Seminary, 1905. Once a thriving asset to Auburn's culture and economy, all that remains of the campus today is the Willard Chapel in the center of this photograph. The chapel features an interior designed completely by Tiffany and is now open to the public for tours, weddings, and events.

The demolition of the abandoned Dodge-Morgan Memorial Library. Originally part of the Auburn Theological Seminary, it was built in 1870–1872 and stood until razed in 1952.

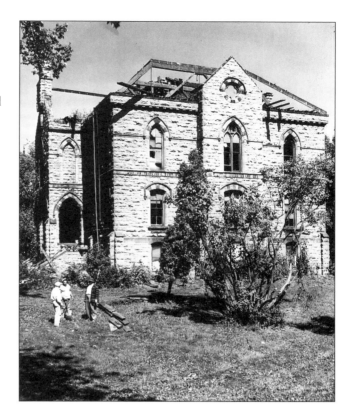

The Flat Iron building, c. 1960. Another distinctive piece of Auburn architecture and a National Register property, it fell to change the shape of the intersection.

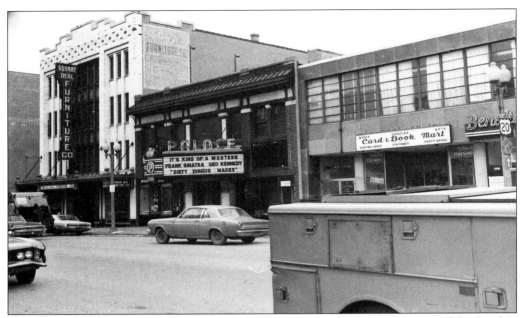

Genesee Street, *c*. 1960s. All of the buildings in the picture with the exception of the Card & Book Mart have been removed.

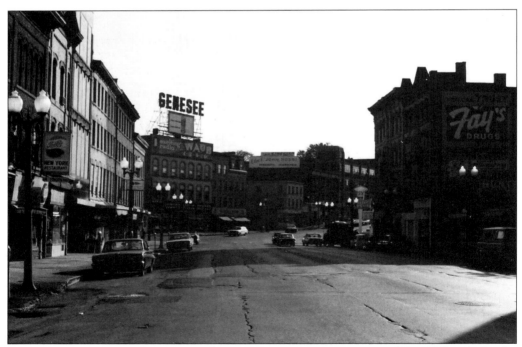

Genesee Street, 1960s. This section of Genesee Street as it curves toward East Hill includes the familiar Genesee Beer sign. What was once a ugly eyesore is now a historic element of the city's skyline.

Three
Inventions, Industries, and Commerce

A grist mill, East Genesee Street, 1880s. This stone grist mill was built in 1825 on the site of Auburn founder Colonel John Hardenburg's original log mill. In 1885, the building was the property of the Lewis & Brewster Company.

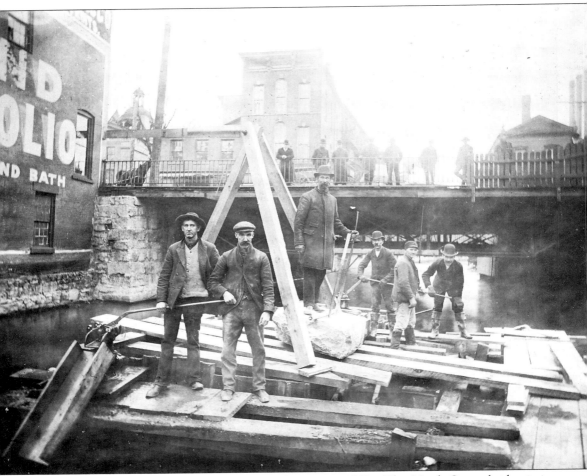

Workmen and a barge on the Owasco Outlet, 1870s–1880s. The North Street bridge is in background. The development of industry in Auburn occurred largely around the available hydroelectric power of the Owasco Outlet. In the mid-1850s, state improvements to a dam above the city limits ensured a ready power source which was essential for most factories until the late nineteenth century.

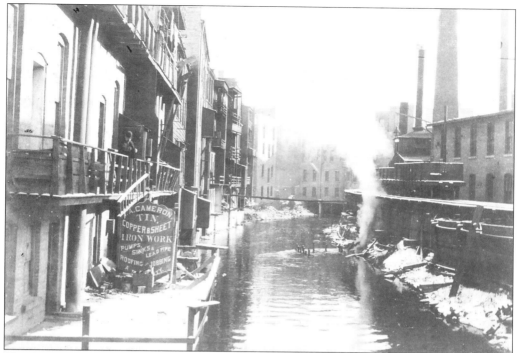

The Owasco Outlet, looking east, c. 1900. This stretch of the outlet near Market Street clearly demonstrates the industrial character of development to Auburn's downtown.

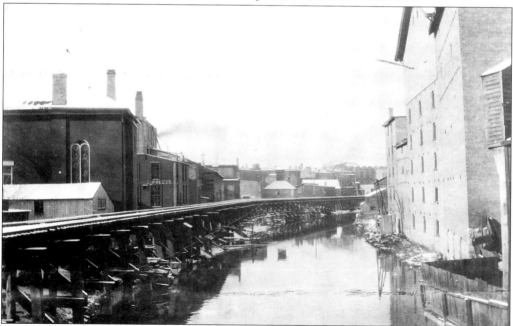

The Owasco Outlet, looking west from the North Street bridge, 1898. The latticework of the wooden railroad trestle is visible at the left. The growth of rail lines followed the outlet through the city to the Osborne Agricultural Works.

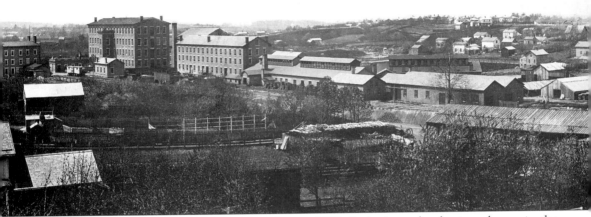

The Josiah Barber & Sons Factory Complex, c. 1870. Barber's woolen business began in the Auburn Prison before laws were put into effect prohibiting the use of prison labor. These factory buildings later became the Dunn & McCarthy Company, a shoe manufacturer noted for their Enna Jettick brand. The remaining buildings burned in a fire in 1993.

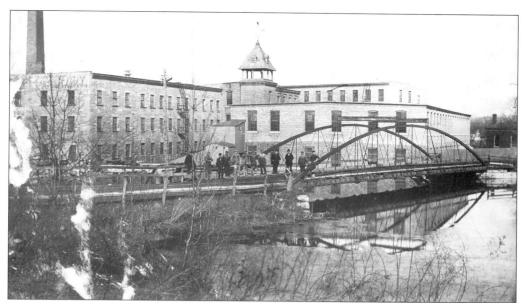

The Nye & Wait Company Factory Complex, 1890s. A partnership was formed in 1871 for the production of carpets at this factory on 11–19 North Division Street. Nye & Wait Company continued to manufacture carpets until 1969.

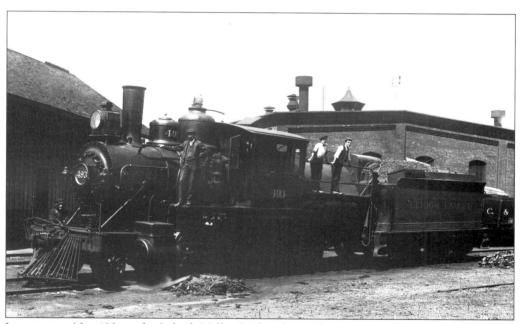

Locomotive No. 493, at the Lehigh Valley Railroad roundhouse near Orchard Street, c. 1902. The development of local rail lines was of great importance to the progress of local industry, and several factories had direct connections from their warehouses to the rail system.

The D.M. Osborne and Company Factory Complex, c. 1900. Once located in the center of downtown Auburn, this company was one of the largest manufacturers of agricultural machinery in the world. It became part of the International Harvester Company in 1902.

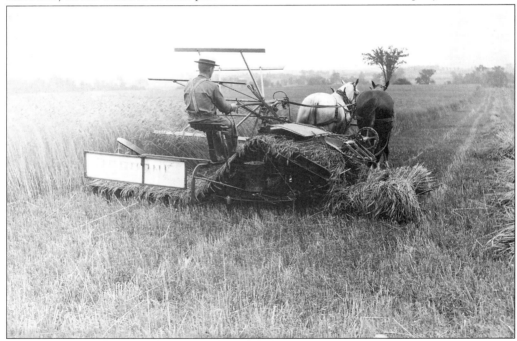

An Osborne reaper, 1880s. This early model of a reaper, possibly one of Cyrenus Wheeler's inventions, was hard at work in fields in Cayuga County and around the world.

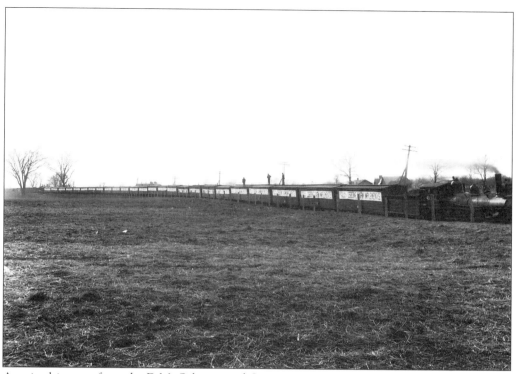

A train shipment from the D.M. Osborne and Company, *c.* 1900. This special train loaded with agricultural machinery is headed for destinations worldwide.

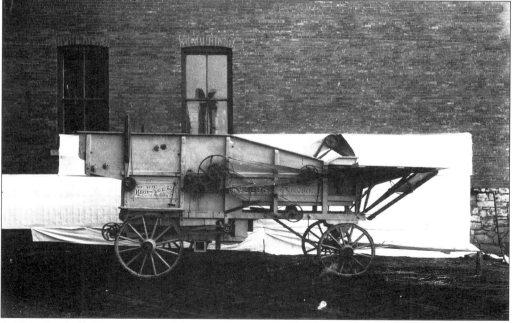

A New Birdsall Company threshing machine, *c.* 1890. This company, located at the foot of McMaster Street, manufactured portable engines, grain threshers, tractors, and sawmills.

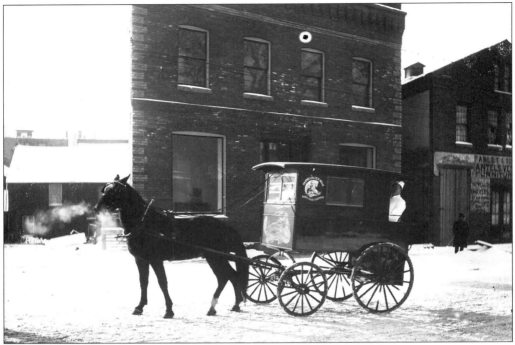

A Cayuga County Dairy Company wagon, *c.* 1916. Another facet of agricultural-related industry in the county was the dairy business. This company produced ice cream and other dairy products at their factory on Franklin Street.

George F. Wills Carriage and Sleigh Manufacturing was located on 81 Clark Street. Wills was in business at this location from 1903 until 1914.

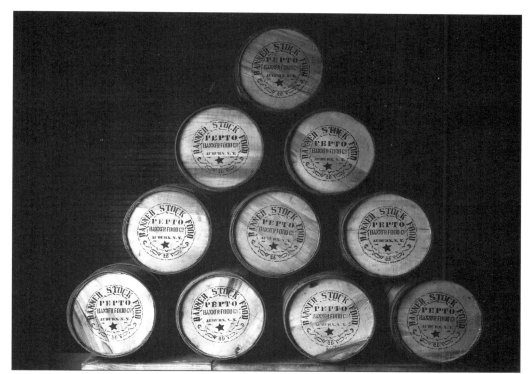

Barrels ready for shipping from the Banner Food Company, *c.* 1908. J.C. Near was the proprietor of this establishment at 25 Elizabeth Street.

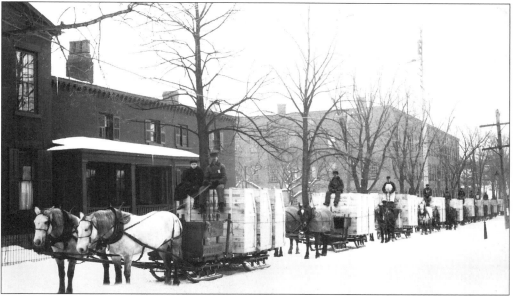

Pianos ready for shipment from the Wegman Piano Factory, *c.* 1910. These eleven bobsleds in line on Logan Street near the factory are each carrying three crated Wegman pianos. The company was active in Auburn until it went bankrupt in 1915. The Wegman building, which can be seen in the background, is used today by a variety of manufacturers.

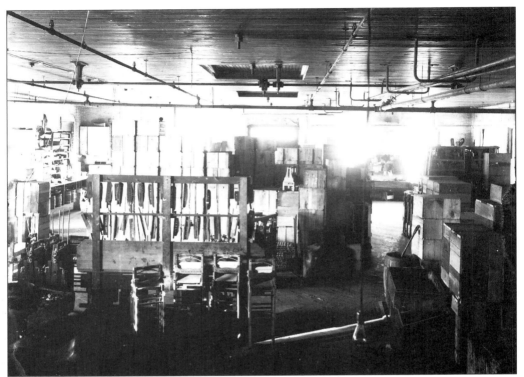

The interior of the Empire Wringer Company Factory, 1880s. This company manufactured purchase gear clothes wringers at their Washington Street factory.

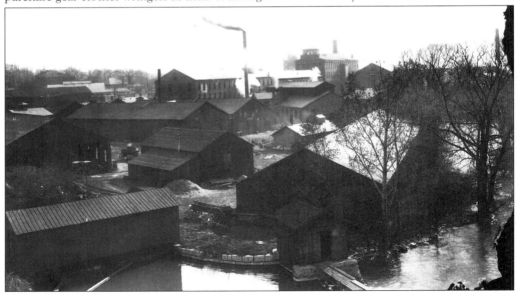

The Washington Street industrial area, c. 1900. This southwestern section of Auburn was one of the areas that had a high concentration of manufacturing establishments. The Lehigh Valley freight house in visible in the distance. The Owasco Outlet, which brought these businesses to these sites, is visible in the foreground.

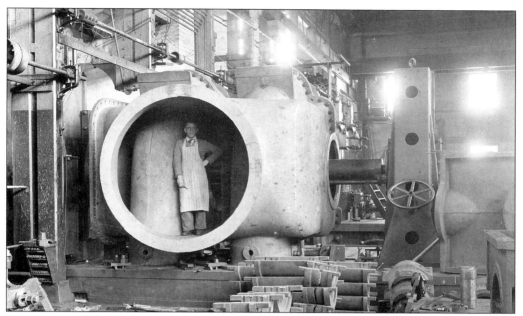

The interior of the McIntosh & Seymour Corporation, c. 1910. Organized in 1886 by John E. McIntosh and James A. Seymour, the company made high speed stationary steam and oil engines for powering factories and ships.

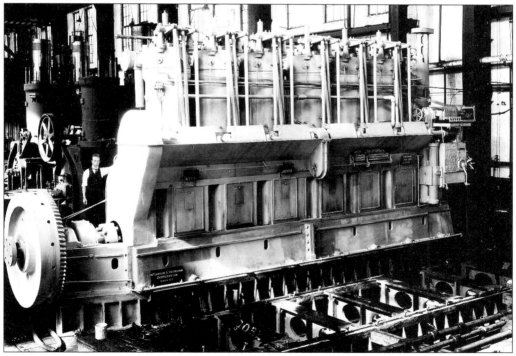

Another view of the interior of the McIntosh & Seymour Corporation. In 1929, the company became part of the American Locomotive Company and began manufacturing diesel engines for trains and ships.

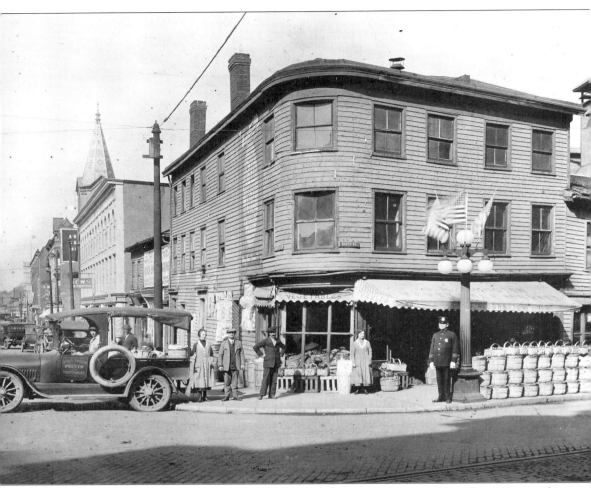

The Johnson Vegetable Market, corner of North and Water Streets, *c.* 1917. This view is to the west up Water Street. This building at 23 North Street was built in the early nineteenth century and went through a variety of uses before it became this corner grocery store.

The saloon at the corner of North and Water Streets, 1909. The building that eventually became the Johnson Vegetable Market is shown here at a low point prior to becoming the market. From 1905 until 1907 it was a corner restaurant and saloon, but was vacant when this photograph was taken. This building can be seen in some of the early views of North Street in the previous chapter.

Another view of the saloon at the corner of North and Water Streets, 1909. The entrance to 23 North Street still displayed a battered Independent Brewing Company sign on its door jamb, a reminder of its saloon days. The Independent Brewing Company was another Auburn industry with a factory on Clark Street.

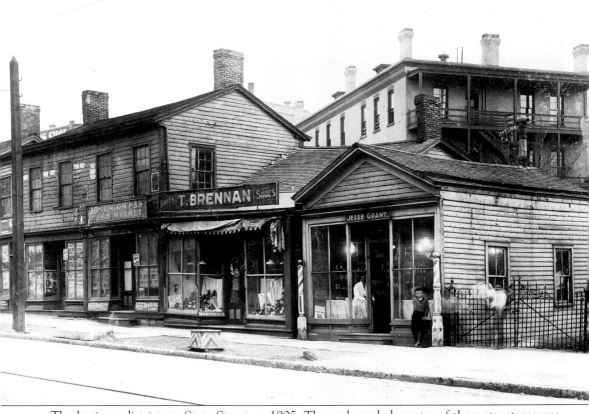

The business district on State Street, *c.* 1905. The scale and character of these structures was typical of many of Auburn's early downtown businesses. The establishments are, from left to right, the Union Market, T. Brennan's Shoe Store, and Jesse Grant's barber shop, with its distinctive painted posts in front.

The *Auburn Daily Advertiser* building, *c.* 1900. Owned by Knapp & Peck, the *Advertiser* competed with the *Auburn News and Bulletin*, the *Evening Auburnian*, and the *Cayuga Co. Independent*. The *Auburn Daily Advertiser* building at 118 Genesee Street is shown here draped for a patriotic occasion.

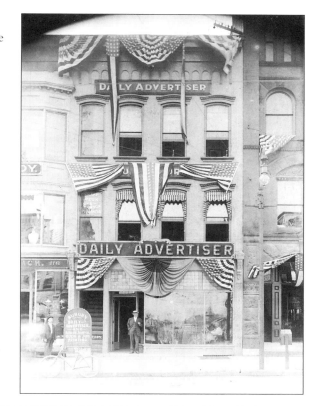

Shea's Restaurant, *c.* 1908. Patrick J. Shea was the proprietor of this eating establishment, which was most proud of its quick lunches in both the ladies' and men's dining rooms. Between 1907 and 1909, Shea had restaurants on both Genesee and State Streets.

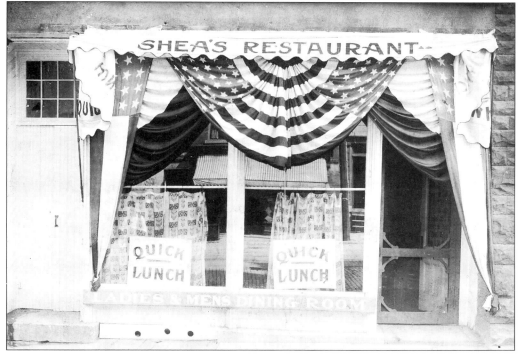

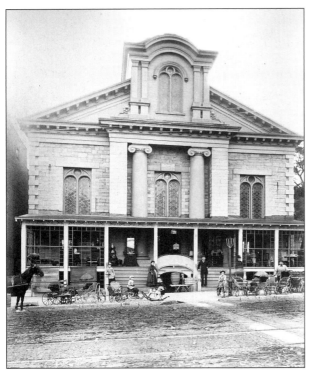

The Traub & Sons Furniture Store, 1885. A wide variety of children's toys and carriages was on display this afternoon at the furniture store, located in what was once the First Baptist Church at 38 Genesee Street.

The S.P. Stevens Coal Company, c. 1906. This business on the east side of South Street was one of several coal dealers in Auburn. The Auburn Savings Bank building is to the left.

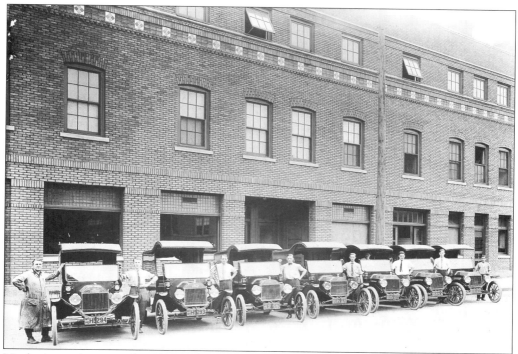

Meaker's warehouse in the 1920s. These vehicles with dapper drivers are lined up and ready to go with a fleet of Model T Fords at Meaker's Garden Street facility.

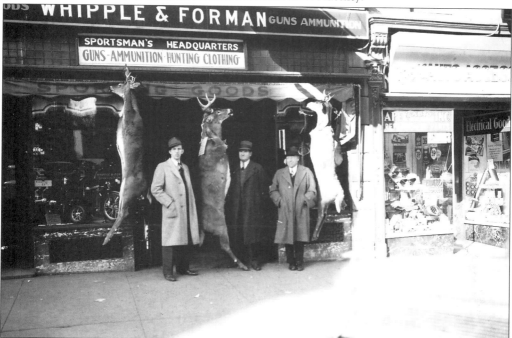

Whipple & Forman Guns and Ammunition, 1940s. The results of a successful deer hunting party hang in front of this appropriate store on Genesee Street.

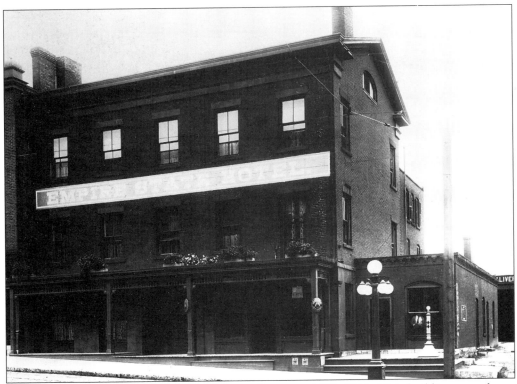

The Empire State Hotel on 32 East Genesee Street, *c.* 1909–1919. This building served as a hotel under many different proprietors before its demolition in 1936.

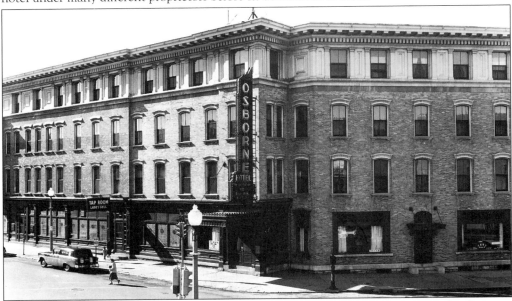

Although the tower was gone by the 1950s, the character of the Osborne House, by this time the Osborne Hotel, was still evident. The building was razed in 1976, together with most of the neighboring structures, to make room for the arterial.

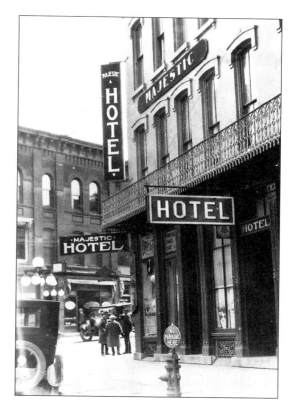

The Majestic Hotel, c. 1920. This easily identified hotel at the corner of Clark and State Streets was in business from 1903 until 1929. In those years, this hotel had to compete with the services of eighteen other establishments within the city of Auburn.

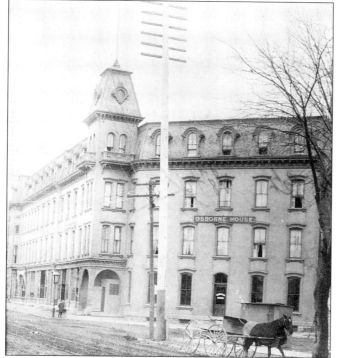

The Osborne House, c. 1870. This earlier view of the long-established Osborne House, on the corner of State and Water Streets, shows its original character with the corner tower and Mansard roof as originally designed.

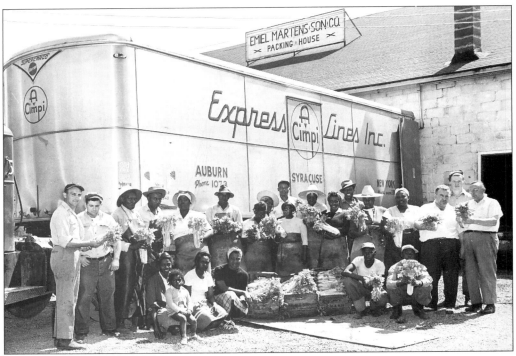

Express workers show off the first shipment of celery for the season at Cimpi's Express Line, Inc., located on Lake Avenue in the 1940s.

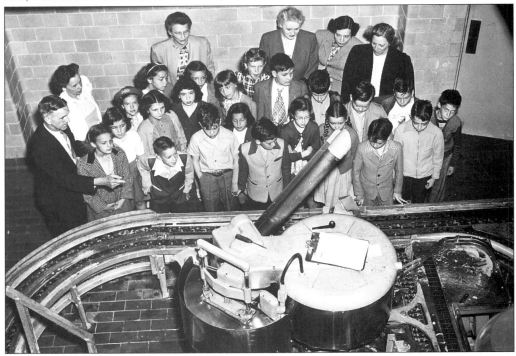

Local school children tour the Dairylea Factory in the 1950s.

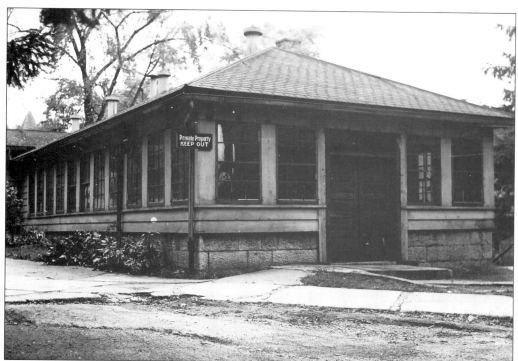

The Case Research Lab, c. 1926. This small backyard laboratory was the site where the first commercially successful method of recording sound film was invented in 1923. Promoted as Phonofilms from 1923–1925, the invention was sold to William Fox in 1926, and achieved its greatest success as Movietone.

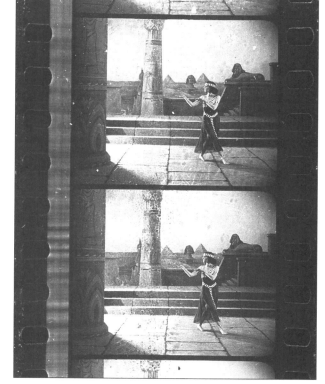

Phonofilm, 1923. This segment of a Lee DeForest Phonofilm is part of the first one ever shown to the public in April 1923. It utilized the Case Research Lab technology for the soundtrack which can be seen to the left between the picture and the sprocket holes.

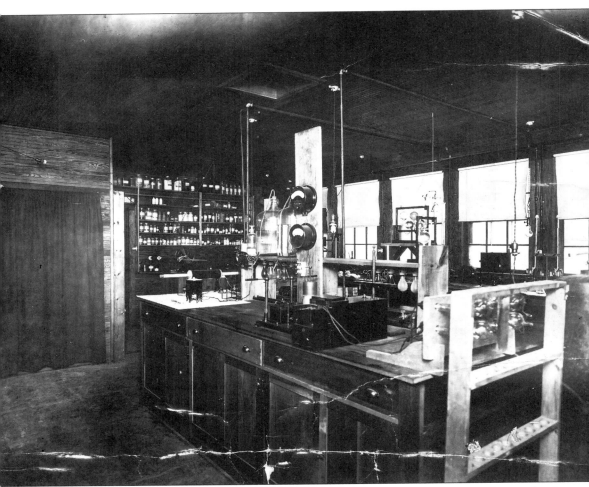

An interior view of the Case Research Lab, c. 1917. The equipment is set up for conducting infrared experiments which led to a top secret signalling system used by the Navy during World War I. After the war, the Case Research Lab concentrated on the invention of sound film, using much of what they had learned from their signalling system.

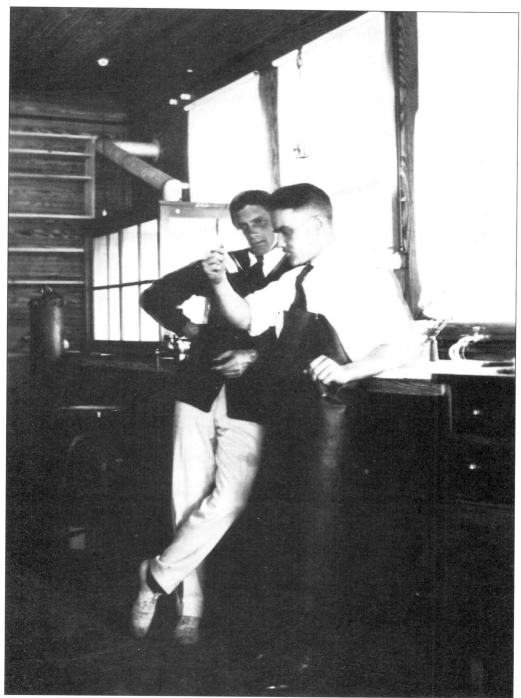

Theodore Case and Earl Sponable at the Case Research Lab, *c.* 1918. Case looks on as Sponable examines an experiment in progress. In 1926, the patents for their sound film invention were sold to William Fox, and the Fox-Case Corporation was set up to handle all Fox sound features and Movietone News.

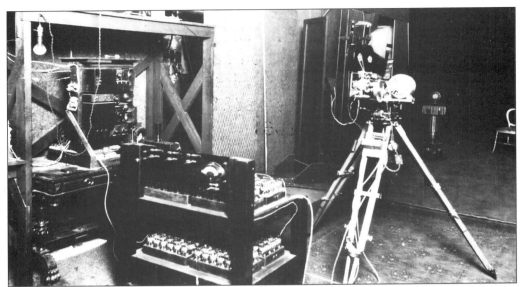

The sound studio of the Case Research Lab, c. 1924. The second floor of the Willard/Case Estate carriage house was transformed into a sound studio in the 1924 for the continued research and perfection of the Case system of recording sound film. Note the Victorian writing table that has been adapted for use as an amplifier stand.

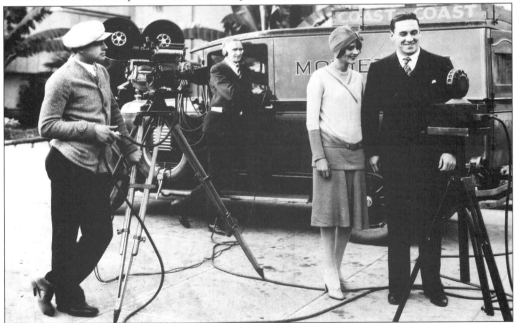

A Fox-Case Movietone News crew, c. 1929, using the inventions of the Case Lab. This news crew is filming June Collyer and George O'Brien at the West Coast Fox Movietone Studios. George O'Brien was one of the stars of the Fox film Sunrise which was the first feature motion picture to have a soundtrack. In the first year of the Academy Awards, Sunrise won three of them including that for "Most Unique and Artistic Picture." That award has never been presented again. Note that Fox-Case can be read on the side of the camera.

Four
A Short Tour
Behind the Walls

The administration building, Auburn Prison, c. 1910. "Copper John," the soldier on the tower, was built by the inmates and sports a secret of which few, other than the inmates, are aware. The administration building survived the riots of 1929 only to fall to the wrecking ball a couple decades later. Copper John lives on, now on the top of the new administration building.

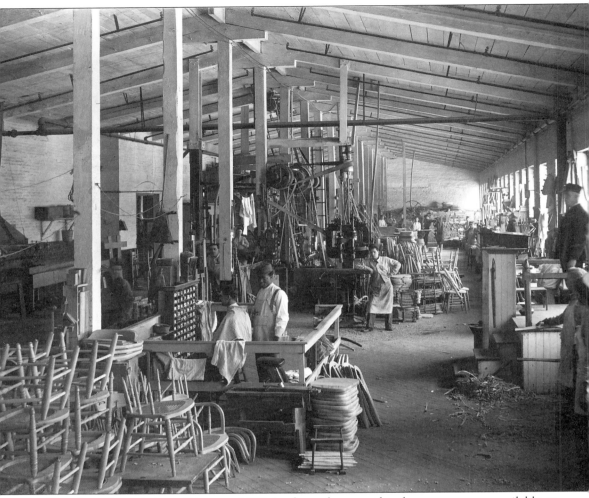

The chair shop, Auburn Prison, *c.* 1880. In the early years, the cheap manpower available at the prison created a manufacturing boom in Auburn. Numerous industrialists from the east established businesses which took advantage of a system in which the prisoners were forced to work and the fees paid to the state for their services were next to nothing. Furniture manufacturing was one of the prison's main industries and one of the few that survives today. The center corral in this photograph is the prison barber shop.

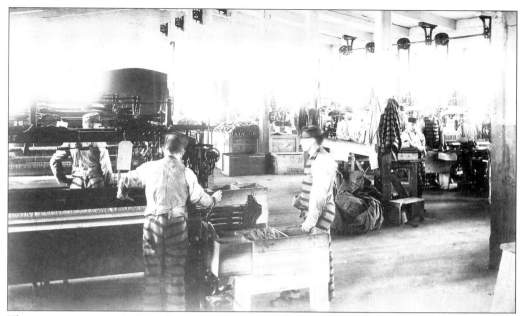

The weaving room, Auburn Prison, early twentieth century. Not only did prisoners actually wear striped clothing, as the old stereotype always told us, but notice also the stylish matching vests.

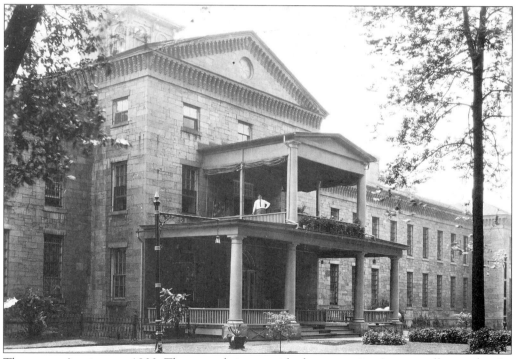

The women's prison, c. 1900. The grounds just outside the state prison's west wall were the site of an asylum for the criminally insane which was later converted into a women's prison. This site is most noted for confining Cat Eye Annie and Mary Farmer, the first woman executed.

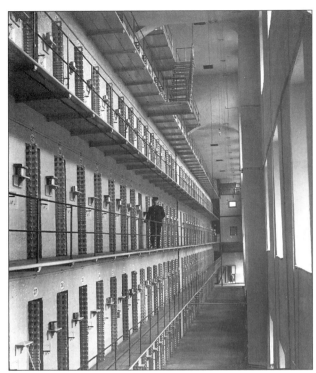

The south wing cell block, c. 1910. While most of Auburn's large industries have folded, moved, or scaled back, the prison has shown consistent growth. First used as an attraction for large industries, it is today Auburn's largest industry.

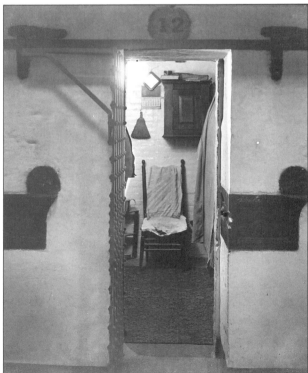

An interior view of one of the men's prison cells, c. 1910. Living conditions were spartan.

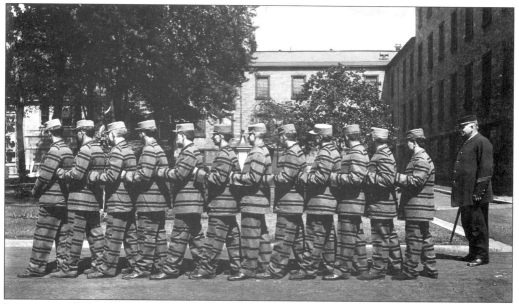

Prisoners in lockstep, c. 1910. Prior to the reformation work of T.M. Osborne, the prisoners were required to walk in lockstep, to work in local factories or at the prison, and never to speak to each other without permission. Talking was the most common inmate violation of the rules and the resulting punishment was severe.

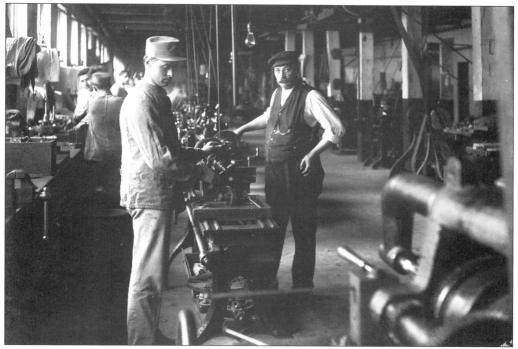

A new prisoner, c. 1910. This picture is from a series of photographs depicting a prisoner's introduction to incarceration. In this view the new inmate is being trained on the operation of a lath in the prison machine shop.

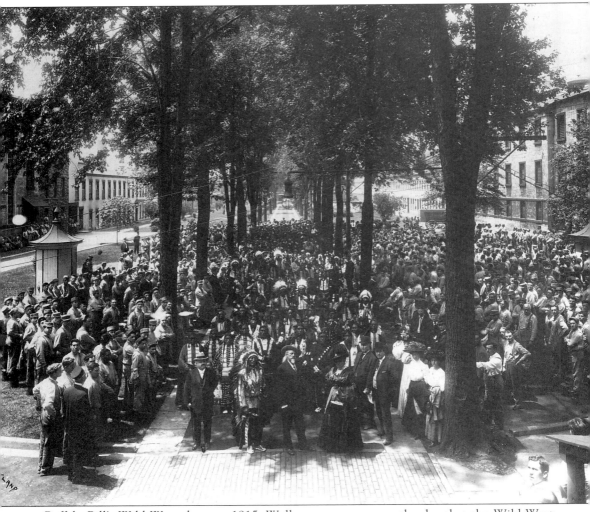

Buffalo Bill's Wild West show, *c.* 1915. Walls were unnecessary the day that the Wild West show held the prisoners captive at Auburn Prison. In the center foreground is William F. Cody with his wife to the right. Warden George Benham is to the right of her. To the left of Cody is Chief Black Hawk and Deputy Warden Allen P. Tupper.

A vaudeville troupe, *c.* 1910. Following the reformation of the New York State prison system, entertainers such as this vaudeville troupe were brought behind the walls to entertain the prisoners. The gentleman in the doorway is not wearing a gas-powered bowler, but simply chose an unfortunate position to pose for this photograph.

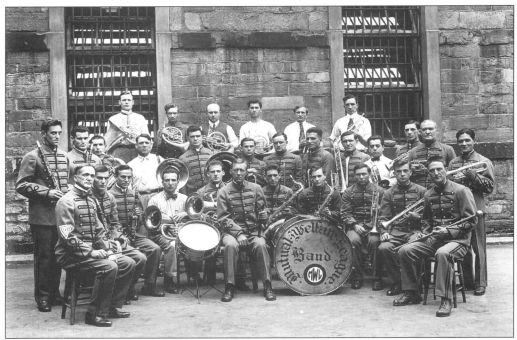

The Mutual Welfare League Band, *c.* 1915. The band, made of prison inmates, played at many prison affairs.

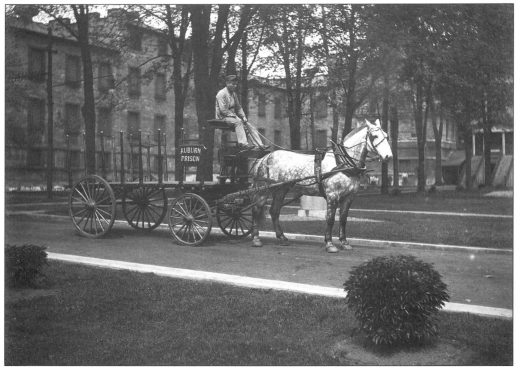

A prison wagon, *c.* 1915, in the prison's center courtyard.

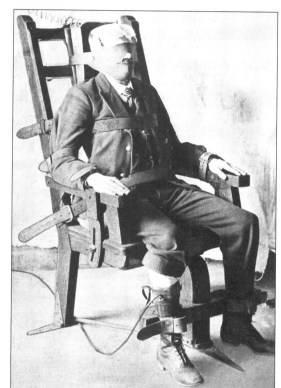

Waiting, 1908. This postcard was printed by Hamilton's Drug Store in Auburn, and it promoted a side of Auburn that the chamber of commerce would rather not advertise. The individual in the chair was not executed. He was simply a trusted inmate who had been cleaning the rooms near the electric chair, and was persuaded by a photographer to pose for this image. The chair was destroyed in the riots of 1929.

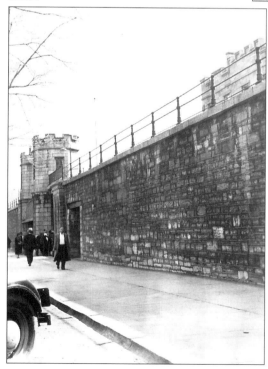

The prison wall, South Street, c. 1920. The octagonal towers on each side of the prison's main gate are the only details that remain today of the site's original structures.

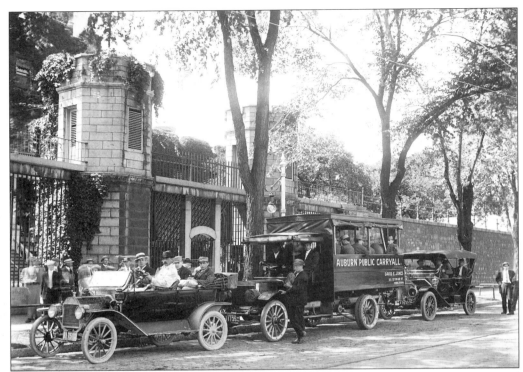

Prisoners being loaded for work detail, c. 1910. Both public and prison transportation was used to transport prisoners to their work sites in the field, known as "Tom Brown" camps.

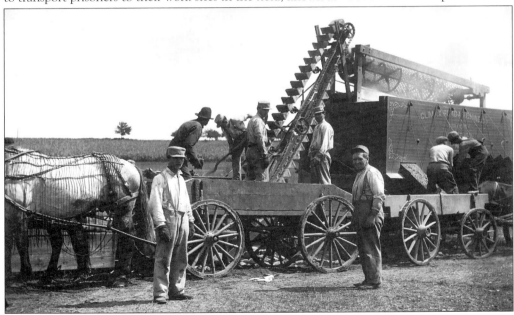

Work detail, c. 1915. Members of the Mutual Welfare League were trusted to work on the Cayuga County roads without being chained together. This crew is working on a portion of the highway near Cato, north of Auburn.

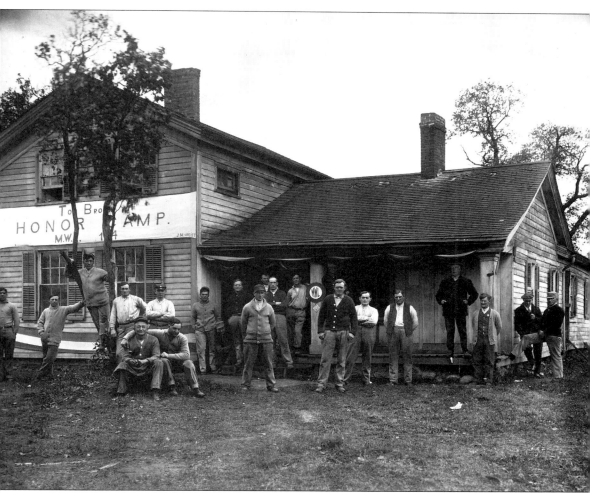

A "Tom Brown" work camp, c. 1915. As a result of reform recommendations by Thomas Mott Osborne, such camps were created for use by trusted prisoners who were allowed beyond prison walls to work on road crews. "Tom Brown" was the name Osborne had assumed when he secretly entered the prison as a convict in order to gain a prisoner's perception of incarceration. The Mutual Welfare League, also formed under Osborne's recommendation, was designed to allow prisoners a voice in prison affairs. It was a governing body of prisoners, and was one of the first attempts at reformation rather than retribution. Ultimately the league failed.

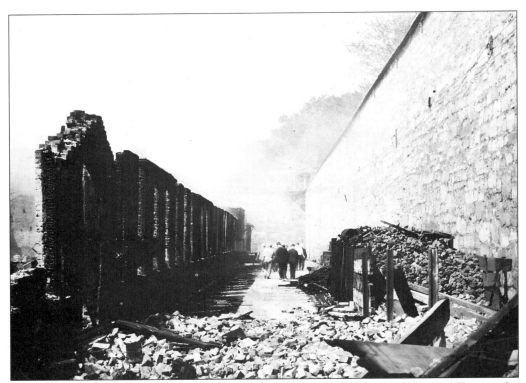

Fire and riot, 1929. Smoldering ruins were all that remained of the Auburn Prison following the collapse of the Mutual Welfare League and a step backwards in reformation. The removal of reform measures resulted in riots and raging fires set by the inmates. Riots erupted twice in 1929, on the coldest and hottest days of the year.

Five

Parades, Processions, and Events

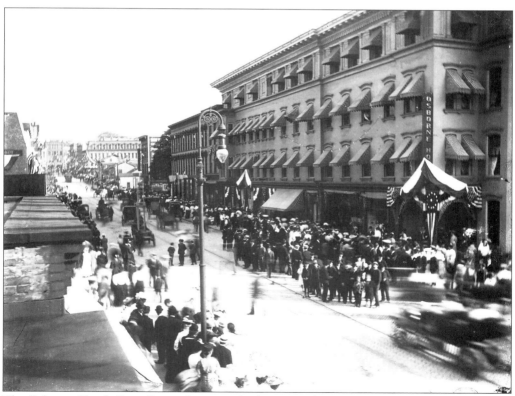

The Osborne Hotel, State Street, June 1906. These crowds are preparing for the parade during Old Home Week.

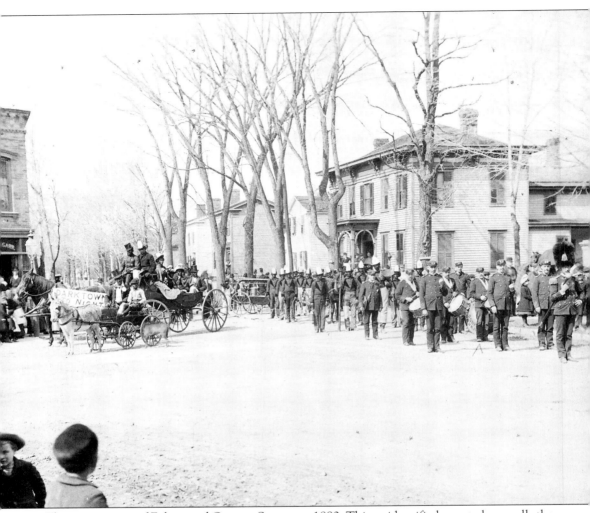

The intersection of Fulton and Owasco Streets, *c.* 1880. This unidentified event also recalls the unfortunate negative stereotyping of some citizens, with several paradegoers sitting in the wagons in blackface as "Darktown" figures.

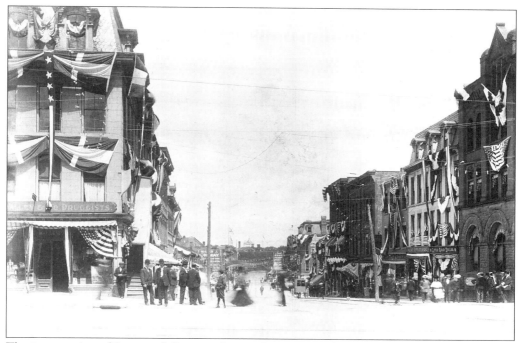

The intersection of State and Genesee Streets, June 1906. The decorative quality of Auburn's streets proved irresistible to photographers during Old Home Week. The top of the prison administration building can be seen in the far center background.

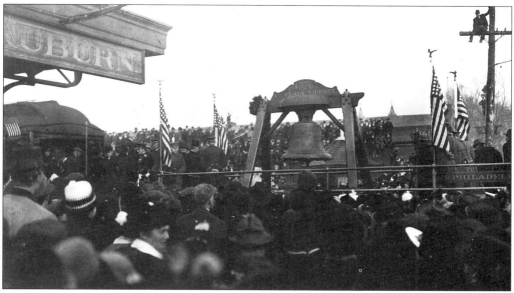

The Liberty Bell at the Lehigh Valley Depot, November 24, 1915.

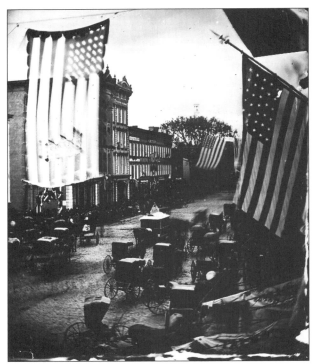

The funeral of William Seward, October 10, 1872. The carriages are shown amassing before the funeral procession. Even pouring rain did not stop people from paying their respects to one of Auburn's, and the nations, most revered citizens.

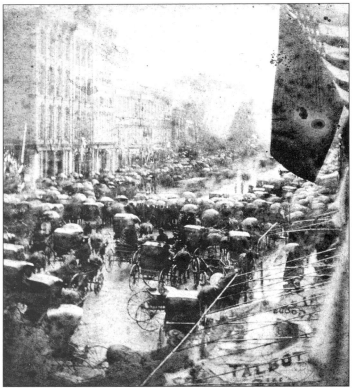

Another view of William Seward's funeral, October 10, 1872.

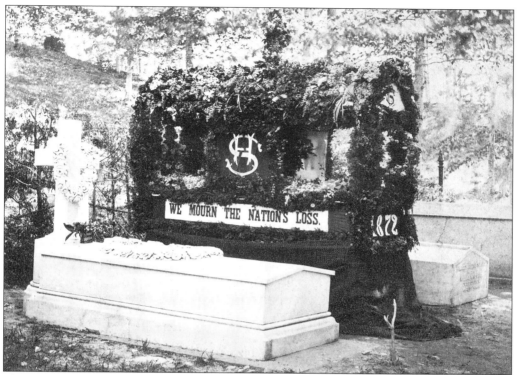

The Seward burial plot, Fort Hill Cemetery, May 30, 1873. Seward's grave was decorated this day by the Seward Corps.

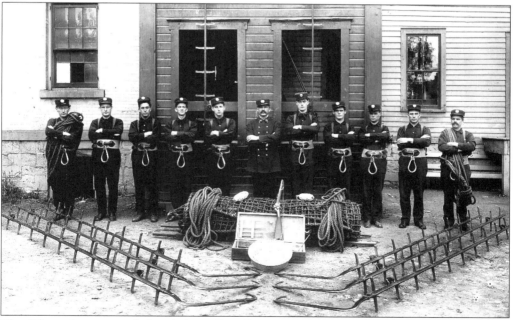

The life saving crew of the Auburn Fire Department, 1907. These determined men are surrounded by six sets of "hooks & ladders."

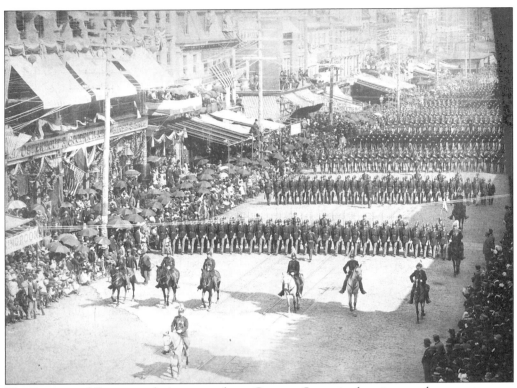

The Provisional Regiment during a parade on Genesee Street in the nineteenth century.

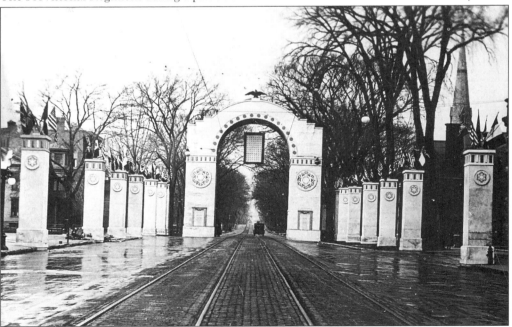

Victory Arch, Genesee Street, 1917. This victory arch, located in front of the old post office, was built in commemoration of the local troops who participated in World War I.

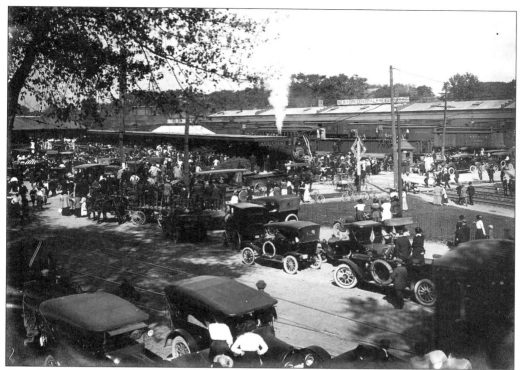

Crowds gathered at the train depot to greet Company M arriving home from France at the end of World War I.

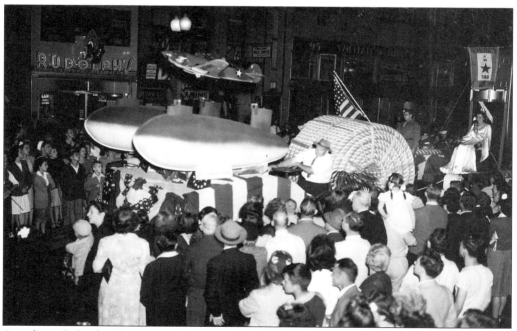

A striking Columbia Rope Company float on Genesee Street in the parade celebrating the end of World War II. Notice the late hour of the day.

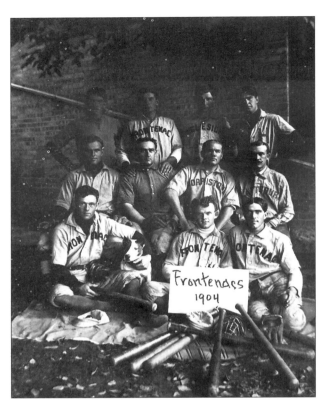

The Frontenac baseball team, Union Springs, 1904.

The Auburn Cyclers indoor baseball team. William B. Patterson (second row, second from the right) was the city manager of Auburn for several years, *c*. 1890s. Note the size of the ball.

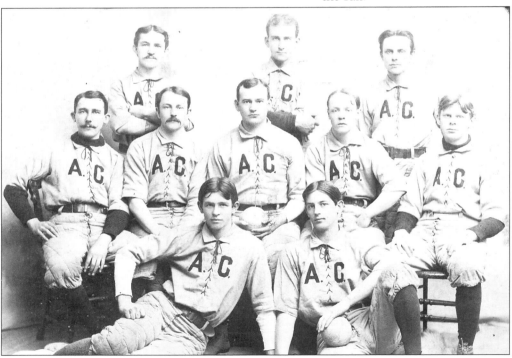

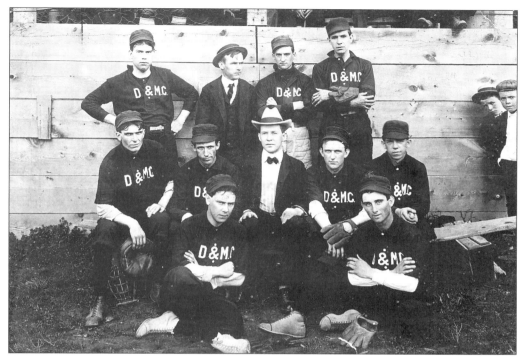

The Dunn & McCarthy baseball team, *c.* 1920, in the years prior to cross training shoes.

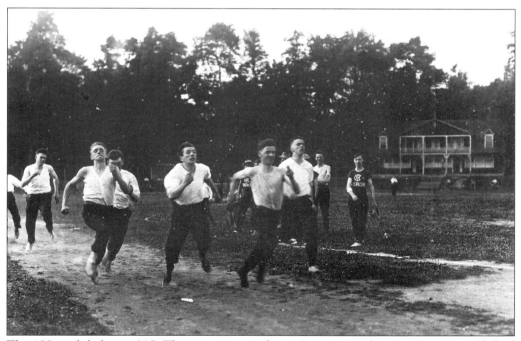

The 100-yard dash, *c.* 1915. This race was run during International Fireman's Day at Clifford Field on Swift Street.

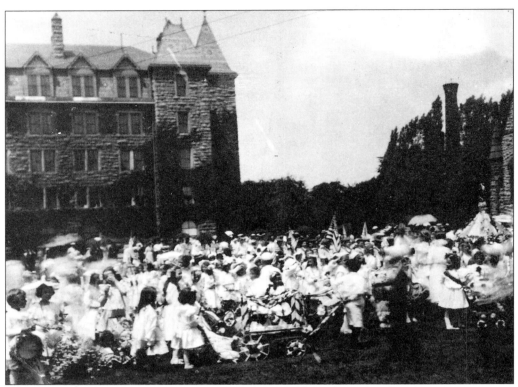

Preparation for the Children's Parade, 1906. These children, dressed in their best costumes, and their anxious parents are gathered on the Auburn Theological Seminary grounds prior to the Children's Parade during Old Home Week.

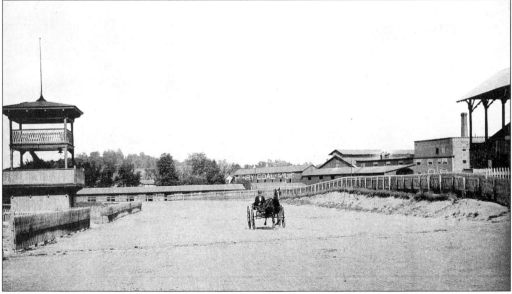

Driving Park, c. 1890. This track was part of the exhibition grounds of the Cayuga County Agricultural Society. The Columbian Rope Factory was built on this property in 1903.

Six

Citizens of the World

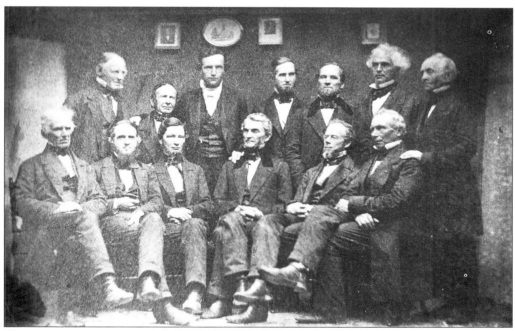

This group portrait is a virtual who's who of Auburn's early movers and shakers. The names of these men are now on the streets and buildings of the city of Auburn. From left to right are: (front row) Dr. Joseph Clary, George Underwood, James Hyde, Sylvester Willard, S.F. Temple, and Daniel Houson; (back row) George Crocker, James Seymour, N.A. Nelson, F.L. Griswald, Harmon Woodruff, Abijah Fitch, and Richard Steel.

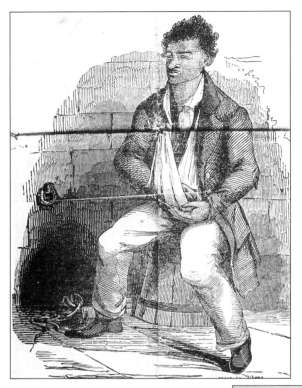

William Freeman, a descendant of the slave family brought to Auburn by John Hardenburgh. Imprisoned for a crime he did not commit, and beaten mercilessly while incarcerated, he swore vengeance on his accusers. Once freed in 1846, Freeman murdered an entire family in their home, only to then be defended in court by William Seward in one of the first cases to use the insanity plea as defense. This illustration is by local artist George Clough.

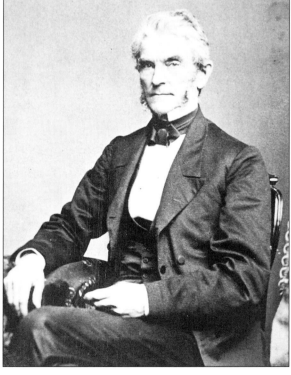

Dr. Sylvester Willard, nephew to the United States Surgeon General of the same name. Dr. Willard was a local philanthropist, physician, and smart investor. A longtime president of the Oswego Starch Company, Dr. Willard lived in the home that is now site of the Cayuga Museum.

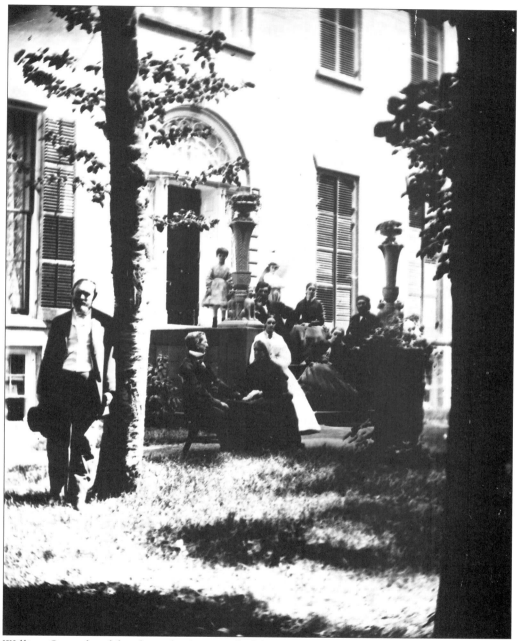

William Seward and family in the front yard of the Seward home on South Street. Because of a carriage accident, Seward was wearing a neck brace which saved his life during an assassination attempt made in concert with the assassination of President Lincoln in 1865.

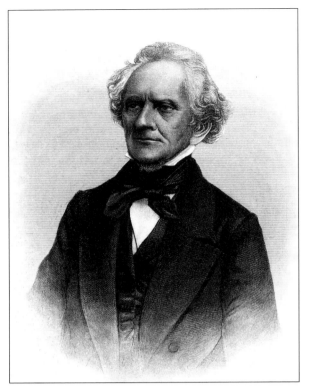

Enos Throop, two-time governor of the state of New York, was appointed Charge' d'affaires of the Two Sicilies by Martin Van Buren in 1832.

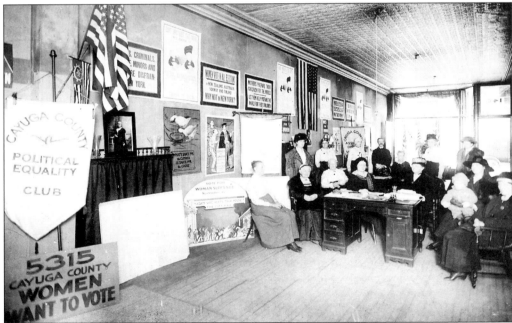

The Cayuga County Political Equality Club on the afternoon that women won the right to vote. Emily Howland (seated second from the left) funded the efforts of her friend, Susan B. Anthony, and served as the president of this club.

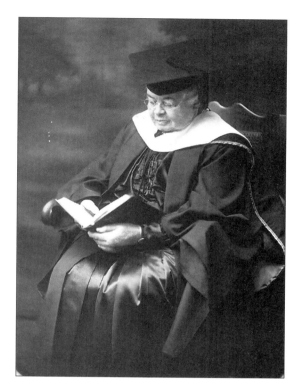

Emily Howland, one of Cayuga County's first independent thinkers. Ms. Howland worked to start schools for freed blacks, gave money to pay for the education of women wishing to study medicine, and worked to bring women the vote. She is shown here being awarded an Honorary degree from Cornell in 1926 at age ninety-nine.

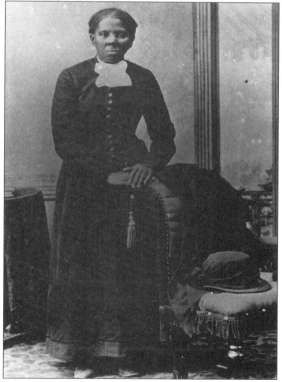

Harriet Tubman, the "Moses of her People," lived in a brick farmhouse on the south side of Auburn for almost fifty years. Now a household name the world over and a figure of respect to all mankind, her remains are buried in a modest grave at Fort Hill Cemetery in Auburn. Auburn was the home she chose, once she was free to choose. Today, the home that she created for the poor and elderly of her race is open to the public as a museum.

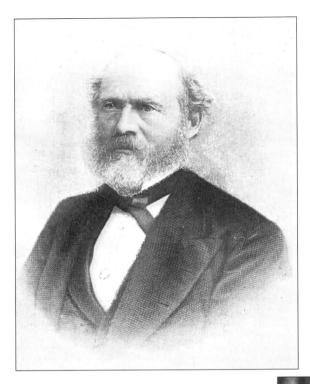

Lewis Henry Morgan, the "Father of American Anthropology." Mr. Morgan wrote the first anthropological study of the Native Peoples of America, and developed the science of Kinship. His book, *League of the Hodenosone* (1851), proved to be a milestone in the understanding of other existing cultures.

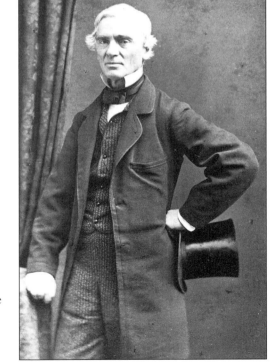

The first president of Wells Fargo, Edwin B. Morgan, was also a United States Congressman from 1853 to 1859. In his home of Aurora, New York, Mr. Morgan created an endowment for Wells College, the school his friend Henry Wells had founded. Another of Edwin's minor contributions to the western world was his founding of *The New York Times*.

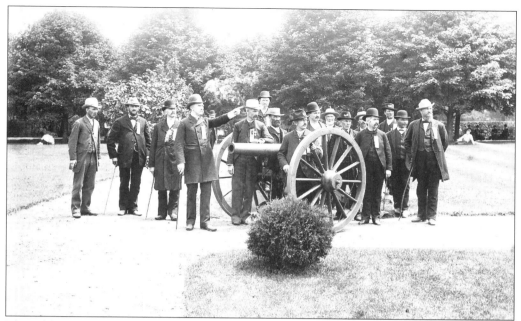

The soldiers of Cowen's Battery at a reunion on the Gettysburg Battlefield. Captain Cowen is the gentleman pointing toward the right.

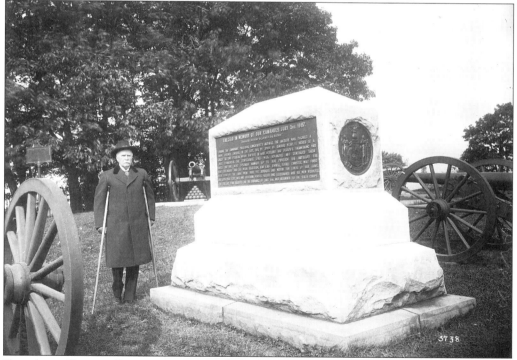

Years later, Captain Cowen was again with the battery he commanded that fateful July. Behind Cowen is the group of trees known as the Angle, or the High Water Mark of the Confederacy. His cane has turned to crutches.

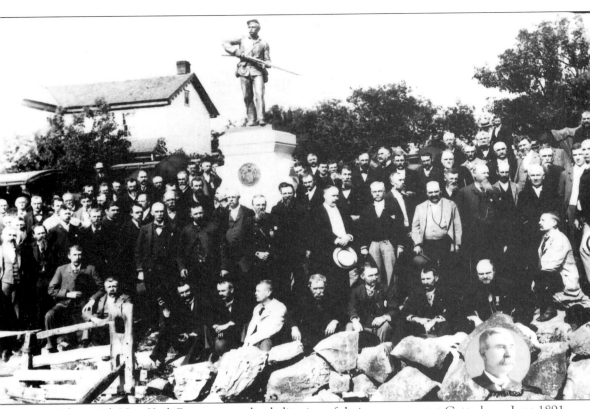

The 111th New York Regiment at the dedication of their monument at Gettysburg, June 1891. This regiment had been long regarded as cowards because of their surrender at Harpers Ferry early in the war. At Gettysburg they were finally able to redeem themselves by standing fast on the front lines and holding back the tide of Pickett's Charge. The ground that they defended was a farm owned by a freed slave. General Clinton McDougal, hero of the Civil War and known to all Auburnians for his extravagant gardens, is shown in the inset to the lower right.

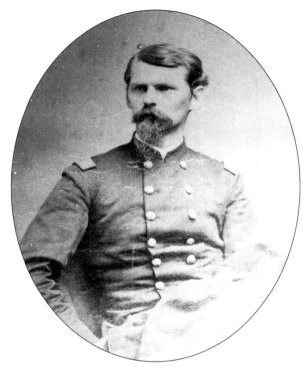

One of the most influential American officers of the nineteenth century, Emory Upton was too young during the Civil War to be fully recognized for his deeds on the battlefield. General Upton created the blitzkrieg style of assault at the Battle of Spotsylvania, in which the soldiers charged in such a rush that they were not allowed to fire their weapons until they overran the enemy. His book *Military Policy of the United States* became the basis for the organization of the armed forces.

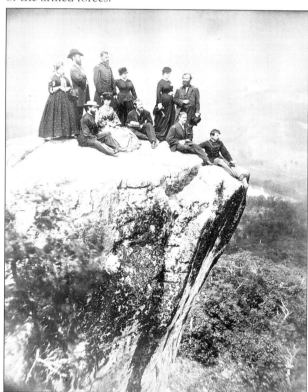

A favorite pose for Union soldiers was at the edge of Lookout Mountain at Chattanooga, Tennesee. In this portrait sits Myles Keogh (to the far right), whose life ended in 1865 at Little Big Horn with Colonel Custer. By a request he made just prior to his death, his body was exhumed and reinterred at Fort Hill Cemetery, Auburn. At the time of the photograph, Keogh served under General Stoneman (standing, third from the left).

95

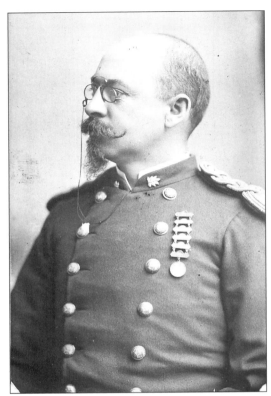

Captain Kirby fought in both the Civil and Spanish-American Wars. During the Civil War, Kirby was taken prisoner only to quickly escape, find his way back to the north, and return to the battlefield once again.

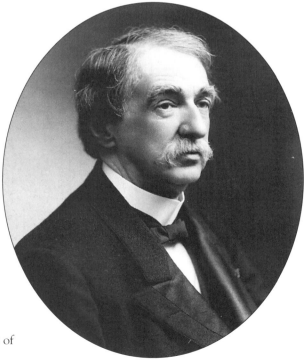

William Seward Jr., a local banker, general during the Civil War, and son of the secretary of state.

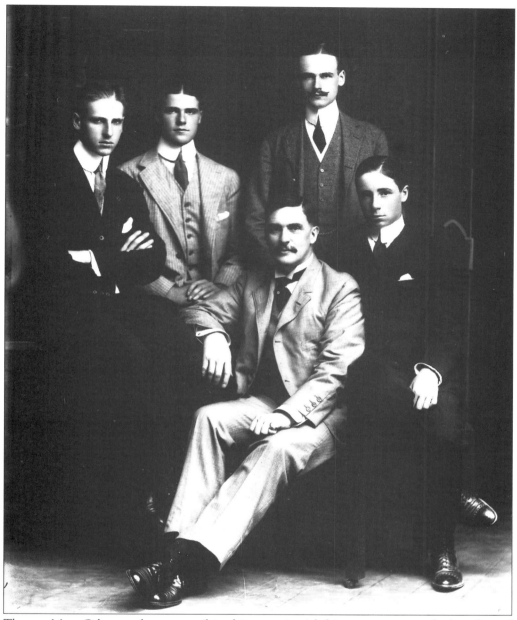

Thomas Mott Osborne, shown seated in this portrait with his sons, was one of a long line of patriarchs to the city of Auburn. He was a prison reformer, actor, candidate for the office of New York State Governor, writer, intellectual, publisher of the *Auburn Citizen* daily newspaper, and son of D.M. Osborne, founder of the Osborne Agricultural Company. The patriarchy has continued to this day into its sixth generation.

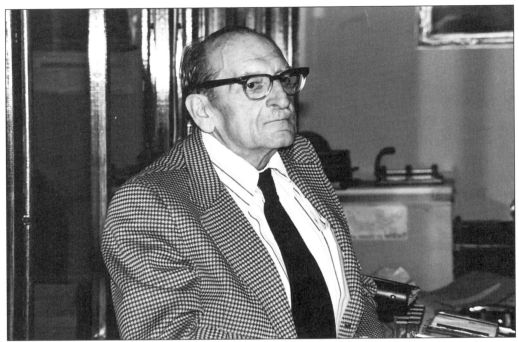

Professor Walter K. Long, director of the Cayuga Museum for fifty years, became as much a part of the history he preserved as that history itself. Colorful and legendary, Walter Long's life was the museum, and it will always reflect some of his character.

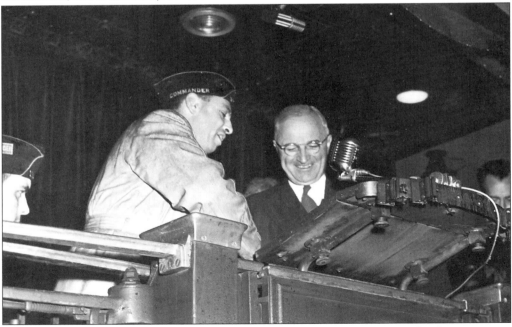

George Michaels and President Harry Truman on one of Truman's whistle stop tours immediately following World War II. Years later as a senator, Mr. Michaels would cast the deciding vote that would make abortion legal in New York. It would end his political career.

General John S. Clark, Aide De Camp to General Banks during the Civil War, was the city engineer of Auburn, a researcher of Northeast Woodland Indians' cultures and sites, and generally a remarkable individual of rare intellectual facilities. His diaries, letters, maps, and notes are in the collections of the Cayuga Museum together with the small remains of his library.

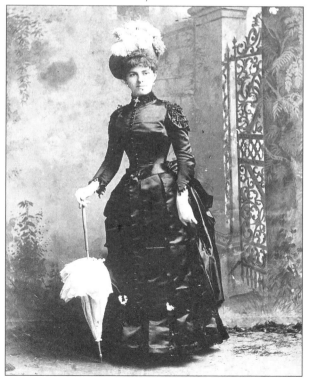

Kittie Rhodes, a well-known stage actress in the nineteenth century, was a native of Port Byron.

The artist George Clough (it rhymes with rough). An individual of unusual artistic talent, Clough painted in a style similar to the Hudson River School but a with twist of his own. Clough studied for a time with Charles Loring Eliot when the latter came to Cayuga County to ply his trade. Clough also studied in Europe and painted for a time in the Adirondacks and Ohio.

James Courtney, master oarsman and native of Union Springs. James and his brother built many of the structures in Union Springs, but he is better known for the records he set as an oarsmen in racing events around the world and in the Finger Lakes. Courtney went on to become the crew coach at Cornell and created one of the best-known rowing programs in the country.

Edward Sanford Martin was raised on the shores of Owasco Lake. As a child, he saw visitors come to his home such as President Grant, Colonel Custer, General Sheridan, and many others that shaped the nineteenth century. He eventually attended Harvard and while there created the humor magazine *Harvard Lampoon* with a few of his friends. Following graduation, he and his friends created *Life* magazine, originally designed as a humor publication.

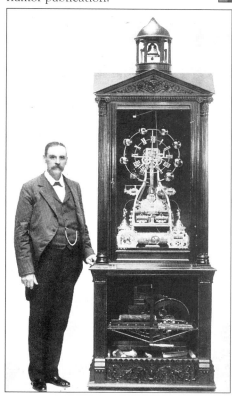

Willard Legrand Bundy created this "Thousand Year" clock to entertain customers at his jewelry store in Auburn. He also invented a time clock that his brother Harlow developed into a mass produced product. The Bundy Time Recording Company, which was formed in Endicot, New York, later became the International Time Recording Company, and then finally the International Business Machine Company. This clock is now at the Cayuga Museum.

Theodore Willard Case was the founder of the Case Research Lab and the man who made sound film possible. He is shown here sitting on the south porch of his summer home at Casowasco, on Owasco Lake. He had a true love for the sciences and dedicated his life to experimenting and inventing.

Sophie Tucker was as rare an Auburnian as she was an American. Known for her unique and brash approach to humor, she was very popular with both male and female audiences.

Seven

North of Auburn

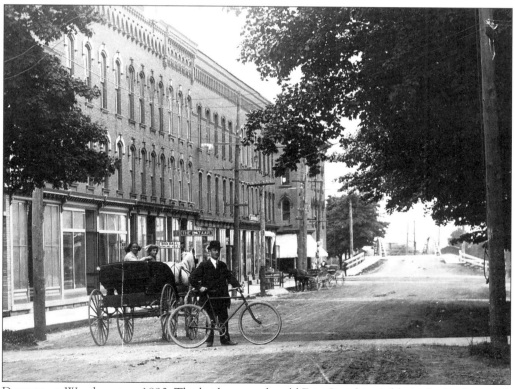

Downtown Weedsport, c. 1890. The bridge over the old Erie Canal is visible in the background.

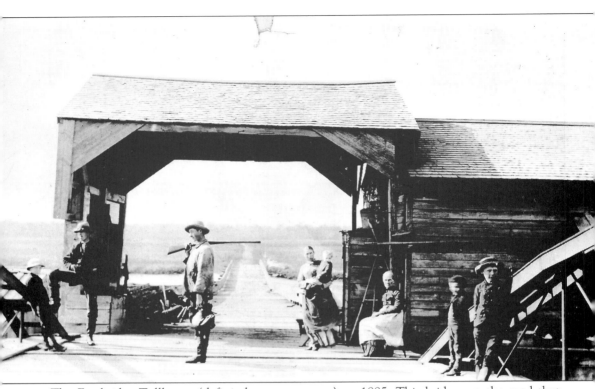

The Freebridge Tollhouse (definitely an oxymoron), *c.* 1885. This bridge, on the road that connected Cayuga and Seneca Counties and later became National Route 20, crossed the Montezuma Swamp just north of Cayuga Lake.

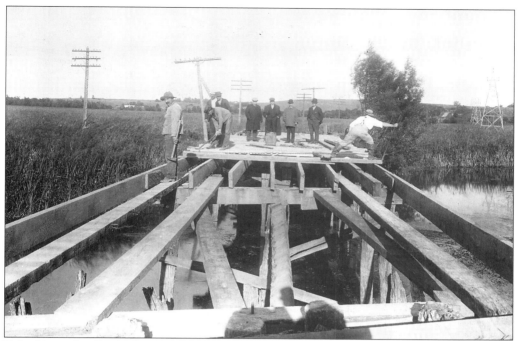

Rebuilding the Freebridge, 1909. Because of yearly damage caused by frost heaving, the Freebridge required costly annual repairs.

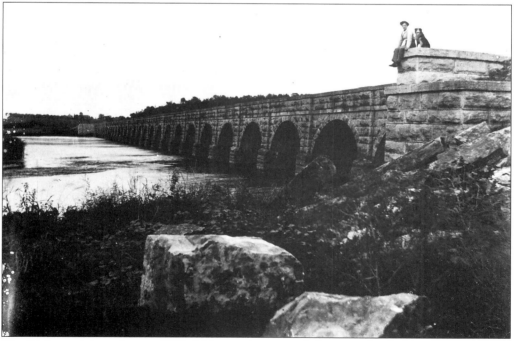

The Richmond Aqueduct, c. 1900. This aqueduct provided passage for the Erie Canal over the Seneca River just west of the village of Montezuma. Only a portion of the structure exists today; the rest had to be cleared to allow use of the Seneca River as part of the present Erie Canal.

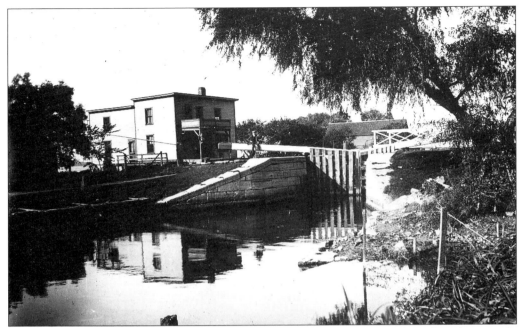

Ward's Store, on the canal in Cayuga, late nineteenth century. The lock in this photograph, which connects the Cayuga Canal to Cayuga Lake in the village of Cayuga, is often confused with Port Byron's Lock 52 on the Erie Canal. A painting by Walter Long of the above lock hangs in the Cayuga Museum.

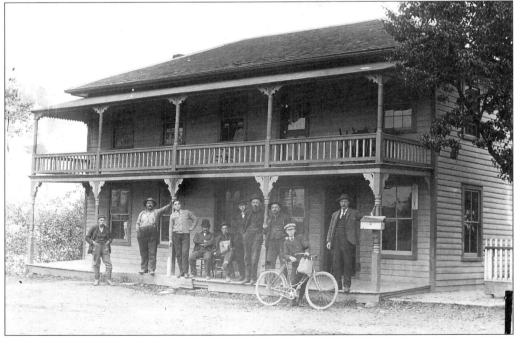

The Inn, Port Byron, c. 1907. The Inn first did business with the Erie Canal and later with the railroad. With both modes of travel now gone from Port Byron, the Inn has long been closed.

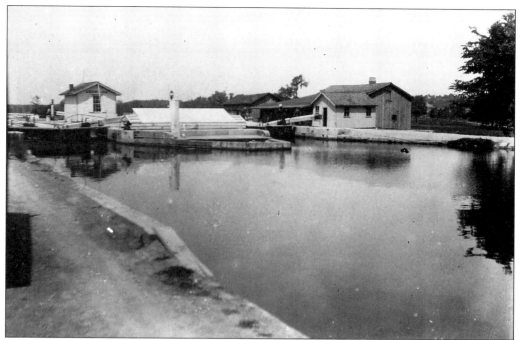

The true Lock 52, west of the Erie House, Port Byron, in the 1920s. As of 1995, the Erie House is being restored. It is the only original inn with a mule barn still in existence on the old Erie Canal.

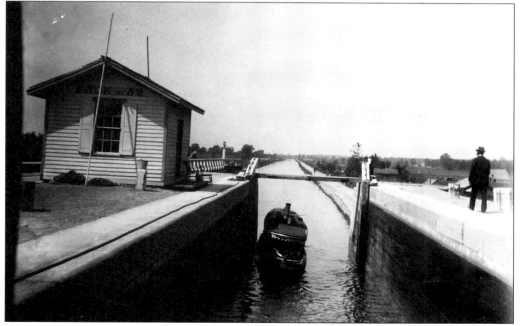

A boat passing through Lock 52, Port Byron, 1920s. This lock now sits on property adjacent to the New York State Thruway, demonstrating how, although modes of travel have changed, the route remains the same.

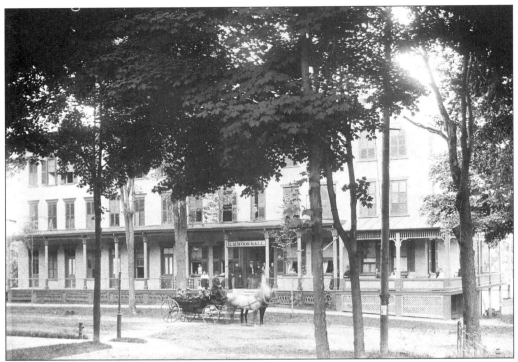

Elmwood Hall, Fair Haven, c. 1880s–1890s. Located at the edge of a great bay on Lake Ontario, Fair Haven was a major port with a grand coal loading dock to serve ocean going ships.

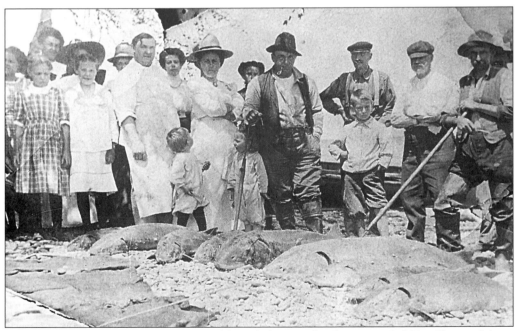

Sturgeon fishing, Fair Haven, c. 1900. Although shipping has long since left Fair Haven, fishing is today a popular recreation which attracts visitors from throughout the Northeast.

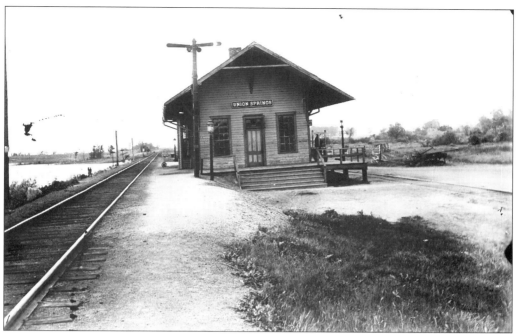

The Lehigh Valley Railroad Station, Union Springs Depot, late nineteenth century. This depot still stands on the edge of Cayuga Lake. The area is now Frontenac Park and the station is the future site of the village offices.

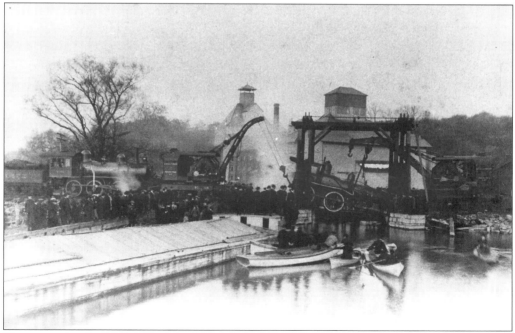

The train drawbridge at Cayuga, built to allow the passage of barges, was the scene of two separate derailments. This picture shows an unfortunate engine being pulled from the waters of the lake after trying to cross the bridge while the rails were raised.

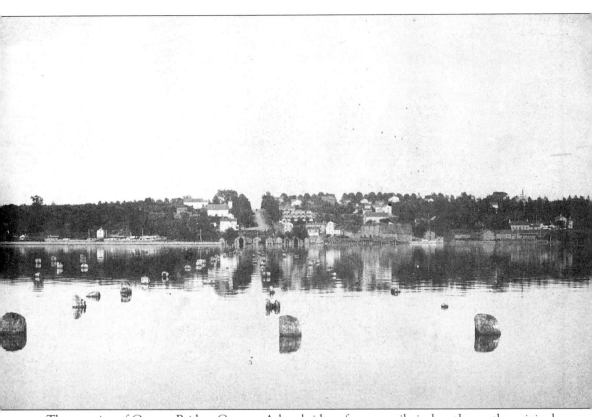

The remains of Cayuga Bridge, Cayuga. A low bridge of over a mile in length was the original route across the waters of Cayuga Lake and the Seneca River. After repeated destruction by ice, the site was abandoned for one to the north over the swamp. Travelers from around the world often marveled at the bridge's length and engineering.

Eight
South of Auburn

The Upper House of the Willowbrook Estate, *c.* 1880. The historic Throop Martin Estate, located on the shore of Owasco Lake, was purchased by future New York Governor E.T. Troop in 1817. The sprawling estate became the focal point for visits by dignitaries from military, literary, and political spheres throughout the nineteenth century.

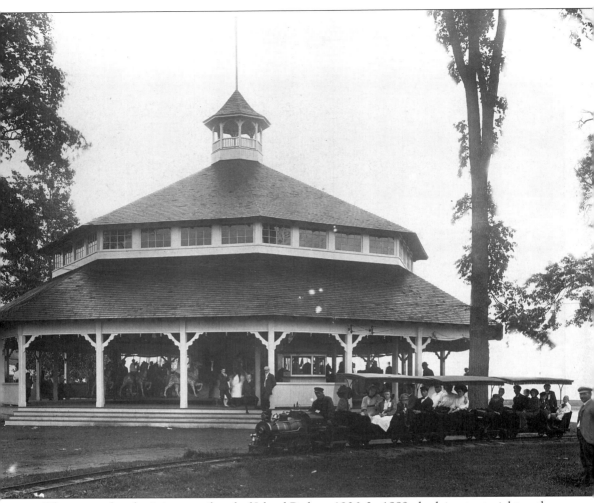

The carousel and miniature railroad of Island Park, *c*. 1906. In 1889, dredging to straighten the channel of the Owasco Outlet resulted in an island, which soon became an amusement park, near the mouth of the outlet. In 1899, William Carmody purchased the island and built a lift bridge to connect his property to neighboring Lakeside Park. By 1906, Island Park featured a summer theatre, a popular hotel, and a tintype gallery in addition to the carousel and railroad.

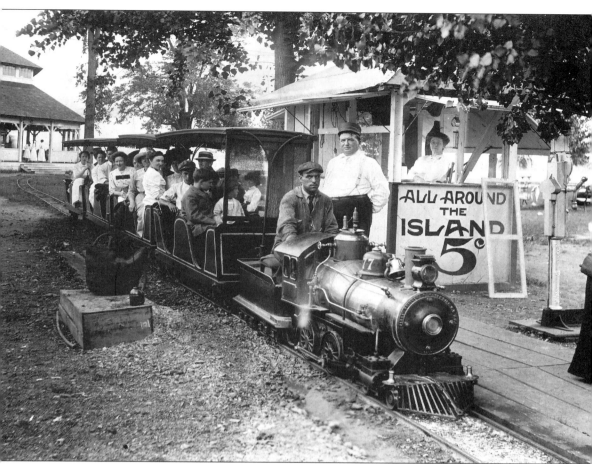

Mabey and West's Miniature Railroad on Island Park, *c.* 1906. The West brothers purchased this miniature steam train following its use in the 1901 Exposition in Buffalo, where President McKinley was supposedly among its riders. The ride, which followed a scenic half mile track around Island Park, was advertised as "the smallest train in the world."

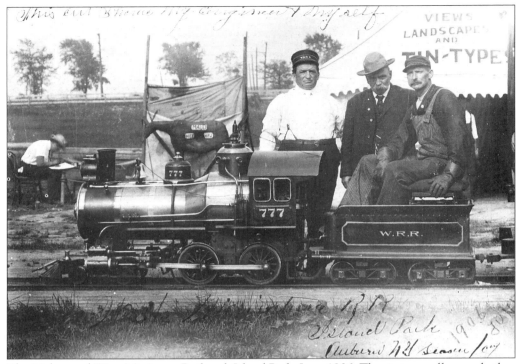

The Mabey and West Miniature Railroad, Island Park, June 1906. The tintype gallery and other amusements can be seen in the background.

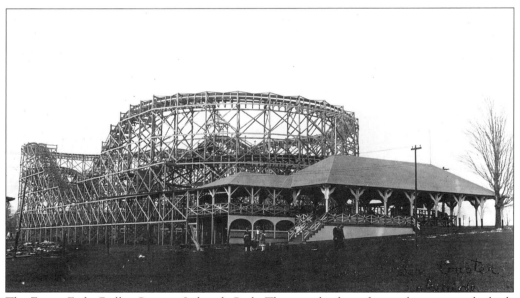

The Figure Eight Roller Coaster, Lakeside Park. This was the first of several coasters to be built at the amusement park on the mainland, at the tip of Owasco Lake. This photograph was taken by C.J. Heiser shortly after the coaster was completed August 1916.

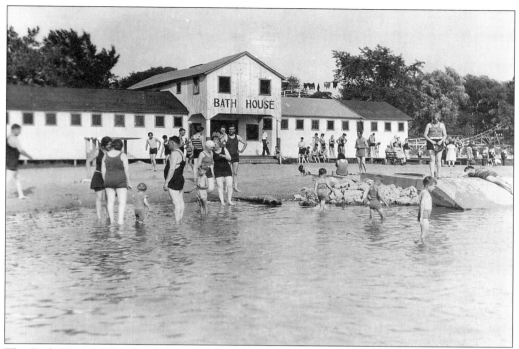

The Bath House, Island Park, 1920s. The Owasco Dips, the second roller coaster at Lakeside Park, can be seen in the background.

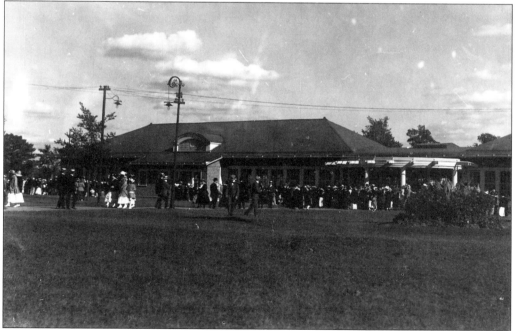

The Pavilion, Lakeside Park, 1910s. This building was a popular spot for community picnics and big band concerts throughout the heyday of Lakeside and the later Enna Jettick Park. It is still used for many activities today.

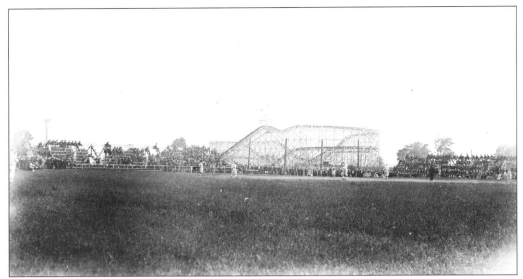

The Figure Eight Roller Coaster, *c.* 1913. A baseball game is in progress in the foreground.

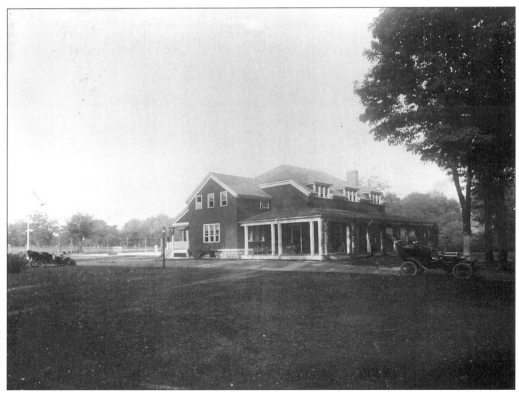

The Owasco Country Club, 1906. Located just east of Lakeside Park, the club features 9 holes of golf and tennis facilities for its members.

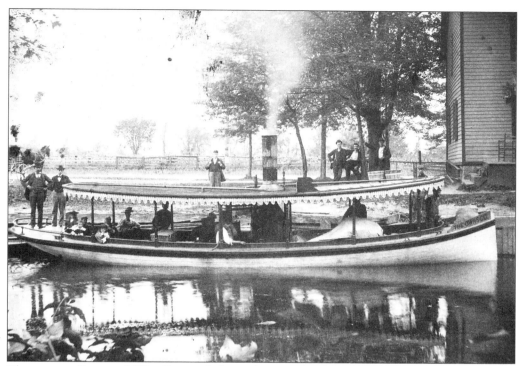

The steamer *Owasco*, 1890s. Owasco Lake in the nineteenth century had a number of steamers to serve passengers for trips to Cascade at the lake's southern end and many points between.

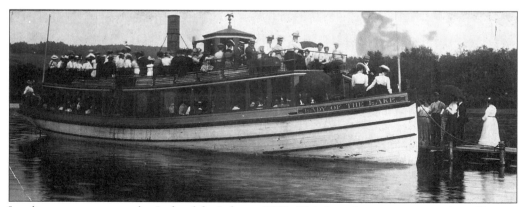

Loading passengers on the *Lady of the Lake, c.* 1890. This famed steamer operated on Owasco Lake from the late 1880s until 1904.

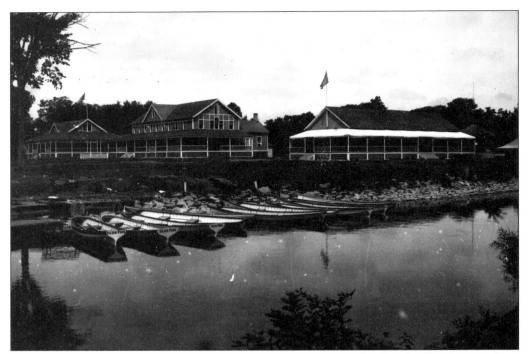

Pleasure boats, at Island Park from the Owasco Outlet, c. 1900. Island Park offered a quiet boat dock and hotel before it was developed as an amusement park.

The Cascade-On-Owasco in the late nineteenth century. This scenic stop on the steamer route and the Southern Central Railroad featured a hotel, visible in the center of the photograph, and resort area that included a waterfall.

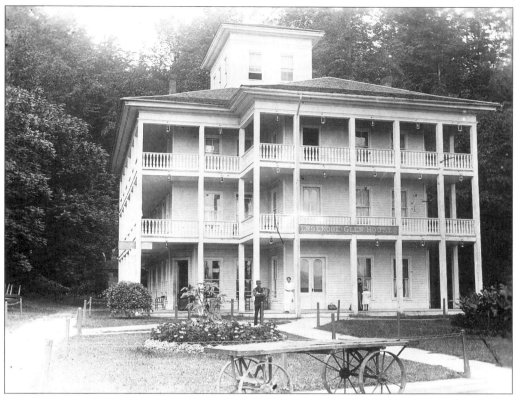

The Ensenore Glen Hotel, *c.* 1890s. This resort on the central west side of Owasco Lake featured scenic trails and waterfalls in addition to dancing, swimming, and boating. It was accessible only by boat and train.

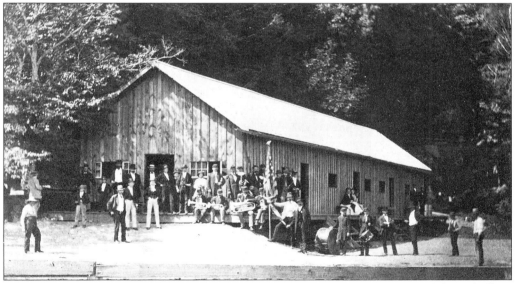

Ensenore Glen Hall, 1870–1880. This wooden frame building was the music and dance hall for the Ensenore Glen Hotel.

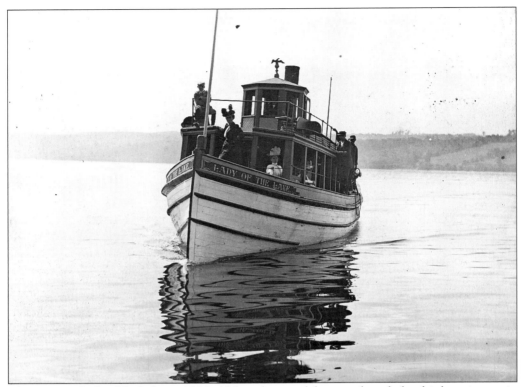

The steamer *Lady of the Lake*, *c*. 1890. Although one of the nameboards for this boat is now in the collection of the Cayuga Museum, most of the boat was claimed by the lake.

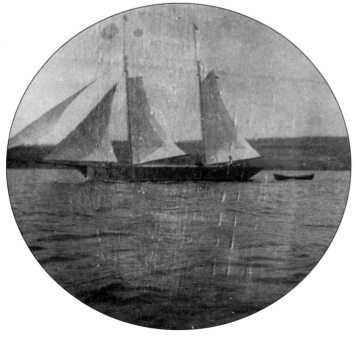

The schooner *Old White Wing*, 1893. Colonel Pete's boat was the only schooner among the members of the Owasco Yacht Club. The club has been active on the waters of Owasco Lake from the late nineteenth century until the present day.

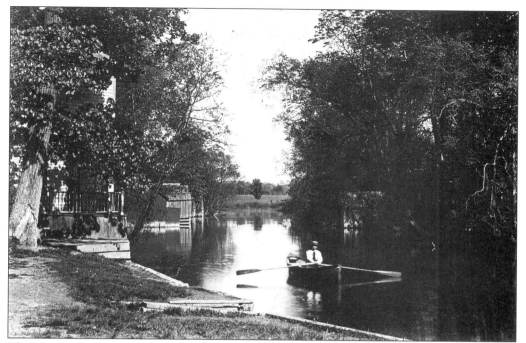

The Owasco Outlet, *c.* 1890. This idyllic view of a boater on the lower end of the outlet is in sharp contrast to the industrial character of the outlet in the heart of Auburn.

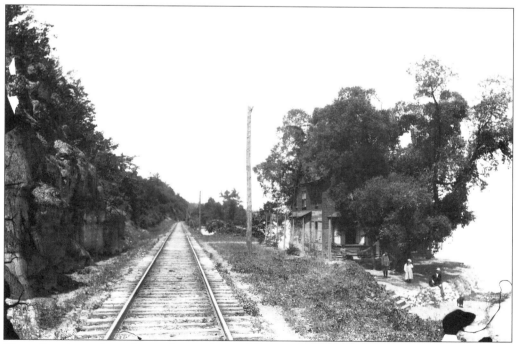

The railroad cut along the southwest shore of Owasco Lake, *c.* 1910. For many years, the only access to the summer homes along the Owasco Lake shoreline was by rail or steamer.

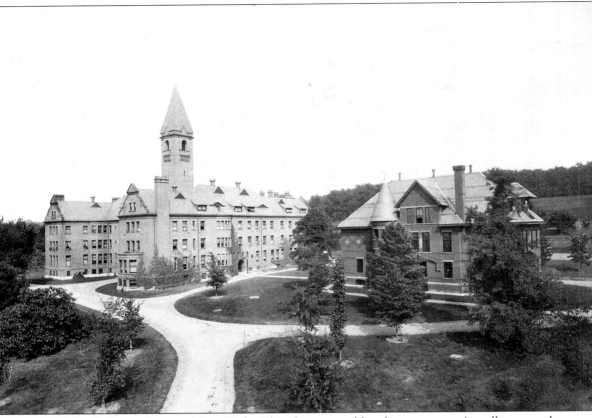

Wells College, Aurora, New York. This four year, liberal arts, women's college on the picturesque shores of Cayuga Lake was founded by Henry Wells in 1868. Wells, who also founded Wells Fargo Express Service, originally named the school Wells Seminary but changed the name to Wells College a year later. Noted financier E.B. Morgan is considered a cofounder for his gift of $100,000 to establish the college's endowment.

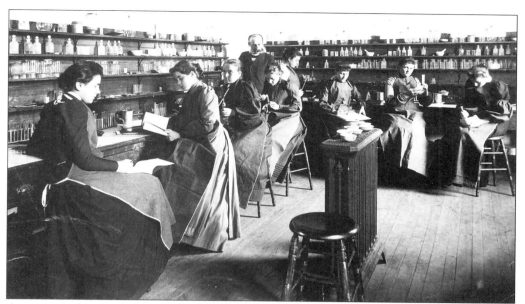

A women's chemistry class, Well College, in the late nineteenth or early twentieth century. Ezra Cornell tried to convince Wells that his college should be in Ithaca, adjacent to Cornell University. Wells resisted, so that his school could maintain its own character.

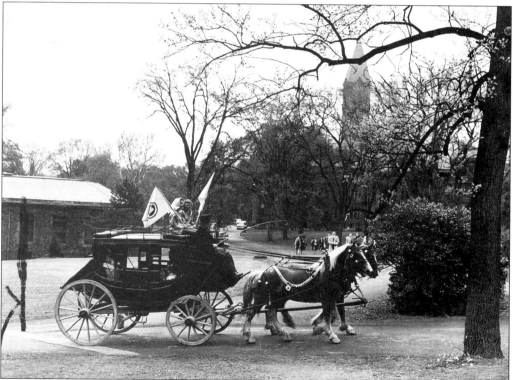

Commencement Day, Wells College, 1950s. It is an annual tradition among graduating seniors at Wells College to ride in a Wells Fargo stagecoach.

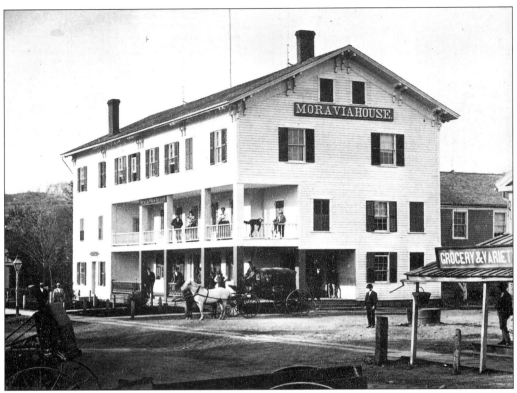

The Moravia House, Moravia, c. 1880–1890. Located in the town where future president Millard Fillmore worked and married, the Moravia House was central to the community's trade.

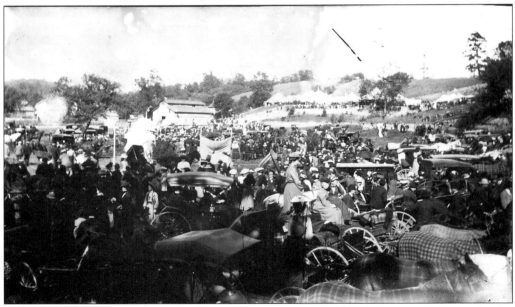

Auburn Day at the Cayuga County Fair in Moravia, August 1900. This annual day at the fair drew a crowd of more than 25,000 persons.

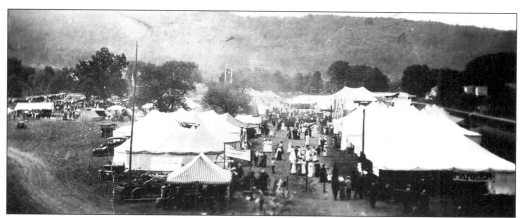

The Cayuga County Fair Grounds, Moravia, *c.* 1920. The Cayuga County Fair, held for a time in both Moravia and Auburn, is now located in Weedsport.

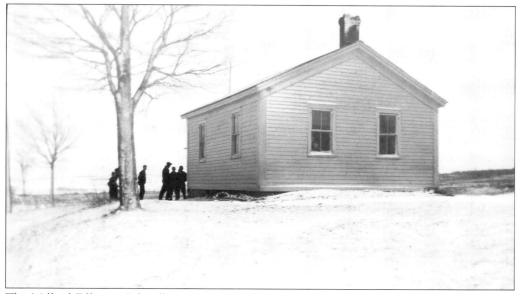

The Millard Fillmore Schoolhouse, *c.* 1930s. This one-room school building, where President Millard Fillmore attended school as a child, was located 1 mile east of New Hope, high above Skaneateles Lake.

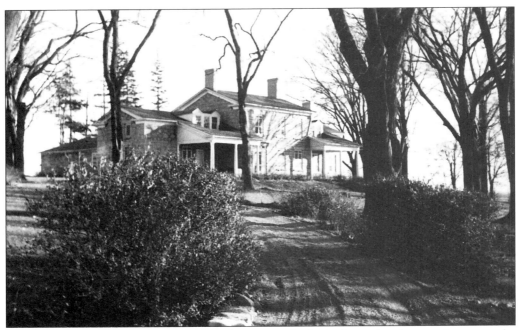

Grinnell Place, Levanna, c. 1930. This house was built in the early nineteenth century by author Washington Irving for his niece and her husband. It is reported the Mr. Irving spent time at this site writing some of his now famous prose.

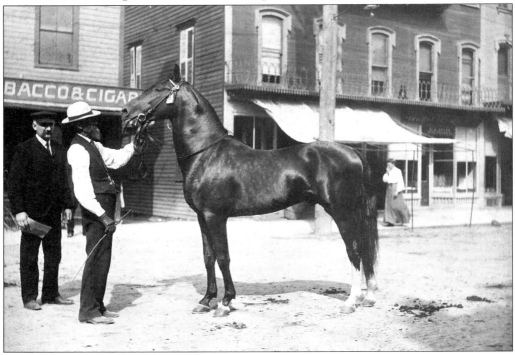

Mr.Charles Bennet with a prize horse, late nineteenth century. This photograph is believed to be of downtown King Ferry.

The Howland Stone Store, Sherwood, 1887–1889. William Howland and John Crowley are on the stone doorstep. The second floor of this building was used as a museum by Ms. Isabel Howland, where she displayed unusual objects she collected in her world travels, and artifacts from the Women's Rights Movement. Her museum is now open to the public.

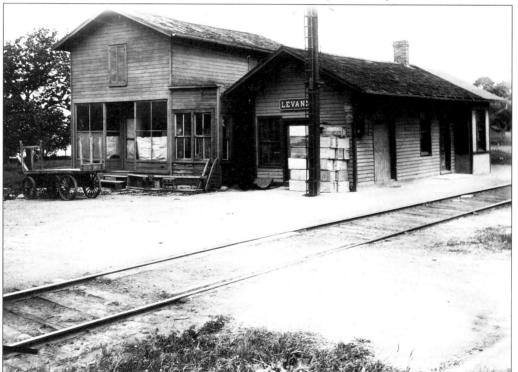

The Levanna Train Station, *c.* 1900. Located on the shore of Cayuga Lake just north of Aurora, Levanna remains but the train and the station have long since disappeared.

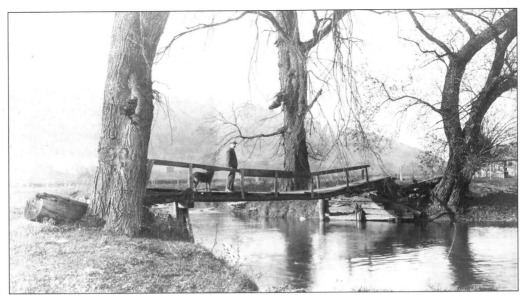

The bridge on the farm of S.D. Merrow, on the inlet south of Moravia. A pastoral bookend.

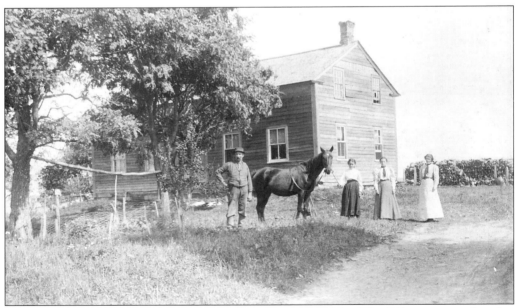

The boyhood home of President Millard Fillmore, town of Niles. The Fillmores moved to this site high on a hill overlooking Skaneateles Lake, shortly after the birth of their son Millard at a site just south of here. This photograph of the later residents of this farmhouse was taken by Iva Barber on September 21, 1898. This, and the log home where he was born, are now recognized historic sites but both of the structures have been removed.